M000266405

IMAGES
of America

FOUNTAIN CITY

IMAGES
of America

FOUNTAIN CITY

J.C. (Jim) Tumblin and C. Milton Hinshilwood

ARCADIA

Copyright ©2004 by J.C. (Jim) Tumblin and C. Milton Hinshilwood
ISBN 0-7385-1649-X

Published by Arcadia Publishing
an imprint of Tempus Publishing Inc.
Charleston SC, Chicago, Portsmouth NH, San Francisco

Printed in Great Britain

Library of Congress Catalog Card Number: 2004102284

For all general information contact Arcadia Publishing at:
Telephone 843-853-2070
Fax 843-853-0044
E-mail sales@arcadiapublishing.com
For customer service and orders:
Toll-Free 1-888-313-2665

Visit us on the internet at http://www.arcadiapublishing.com

CONTENTS

INTRODUCTION

In 1788, the State of North Carolina granted John Adair a 640-acre section of land in recognition of his services to his country. Land grant No. 28 gave him one square mile of wilderness land in Grassy Valley that extended from the present Fountain City Business Park to the Gresham Junior High School campus.

The city that would become Knoxville was born in 1786 when James White established White's Fort on the banks of the Tennessee River (then called the Holston) between First and Second Creeks. It was only two years later that John Adair (1732–1827) established Fort Adair on his land just one mile south of the area that would become central Fountain City many years later.

Adair's Fort was designated a supply base for the Cumberland Guard, which was responsible for protecting settlers from North Carolina and Virginia as they moved toward the Cumberland Settlements at present-day Nashville. The fort stored corn, flour, pork, and beef to supply the families as they moved through the wilderness. The area was sparsely populated over its first century. Then the Fountain Head Improvement Company received a charter giving them the right to develop a park and resort in July 1885. Stephenson and Getaz, architects and builders, drew up plans for a splendid hotel building three stories high with 40–50 rooms. Several guest cottages were planned and erected over the next few years. The Fountain Head Hotel, built overlooking the beautiful wooded park and campgrounds, was ready for occupancy in the spring of 1886.

Interest grew again when the Fountain Head Dummy Line made its first run in 1890. As transportation became faster and easier, Knoxville businessmen first built summer residencies in Fountain City and later established year-round homes. Among those who built permanent homes were John W. Hope, jeweler; Col. J.C. Williams, coal magnate; W.T. Hall, clothier; and Sol George, department store owner.

The Dummy Line made a stop at Smith's (Smithwood), and the busy Tazewell-Jacksboro Turnpike, a macadamized toll road, ran through Smithwood and Beverly. With better access and transportation, that area developed faster than the area around the lake and park. The George, McMillan, Caldwell, Kesterson, Anderson, Tillery, Conner, Rochat, and Truan families and others built on or near Tazewell Pike.

A real estate boom developed in 1890, when Col. J.C. Woodward of Lexington, Kentucky, and a group of capitalists bought 431 acres of land in Fountain Head at a cost of $159,600. They launched an extensive advertising campaign in the Knoxville newspapers stressing pure water,

beautiful trees, and a pleasant climate, prompting a number of new families to build homes around the Fountain Head Park area.

There was a lot happening in 1890 with the Dummy Line operating, the hotel open, and busy real estate sales. That same year the United States Post Office was established and the name changed to Fountain City to avoid confusion with another Tennessee town called Fountain Head in Sumner County.

The resort season of 1891 is remembered as the best season ever enjoyed by the Fountain Head Hotel. However, the *Knoxville Blue Book* (1894) listed only 70 permanent residents. No curative powers were claimed for the water from the Fountain Head Spring, as was the case with several resorts with mineral springs all over East Tennessee. Regardless of that, some of Knoxville's most prominent families took advantage of the cool summer breezes, the hospitality, and the delicious 50¢ meals prepared by Mary Donahue.

Holbrook College opened in 1893 with an enrollment of more than 100 students and, by 1900, the central business district along Hotel Avenue was being developed. Central High School purchased the building and grounds of Holbrook College and opened there in 1906. Fountain City's future was assured. By 1940, there were 40 businesses along Broadway alone. Slow, but steady, growth continued until the population had reached 30,000 by the time the suburb was annexed into the City of Knoxville in 1962.

Fountain City continues to have a personality of its own. We hope the photographs and postcards presented here will reveal its heart and soul. Join us for a nostalgic journey through time.

One

JOHN ADAIR AND
HIS DESCENDANTS

John Adair served his community and state in numerous ways; he was a member of the county court when it was formed in 1792, a member of the Board of Trustees of Blount College (later the University of Tennessee), and a member of Tennessee's first Constitutional Convention in 1796. An original elder of the First Presbyterian Church of Knoxville, he was a fellow parishioner of Knoxville's founder, James White.

Mary Adair, John Adair's daughter, married Capt. Robert Christian. They had several children, including Mariah (1802–1883), who married John Smith (1795–1883) in 1819. Smith was born in Culpepper County, Virginia, but lived in the Beaver Dam settlement. A harness-maker by trade, he purchased 474 acres for $1,000 from Adair on December 2, 1820, and farmed the land for many years. The Smithwood community is named for him, as is the Smithwood Baptist Church of which he was a deacon and benefactor.

Adair's great-grandson, James Harvey Smith (1840–1932), was prominent in civic and religious affairs in Smithwood. Lieutenant Smith, a Civil War veteran of the 1st Tennessee Cavalry (USA), was a charter member of Shannondale Presbyterian Church. Three daughters and three grandchildren survived him. Author and naturalist Harvey Broome, one of his grandchildren, said of him, "Grandpa was someone special. He had been a cavalryman in the Civil War. But he was always a farmer. He could shoe a horse, cradle a field of wheat, make a pair of shoes, slaughter a pig, milk a cow, chop wood, grind a blade, grease a wagon, and handle a horse with certitude."

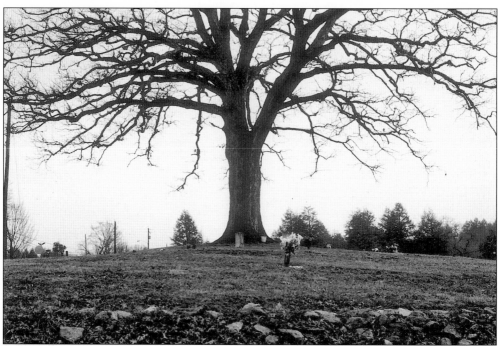

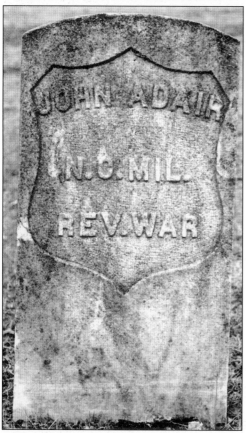

JOHN ADAIR BURIAL SITE IN LYNNHURST CEMETERY. This is the "high ground" on the southwestern side of Adair's acreage and the most likely location of Fort Adair, although the exact location has not been fully established.

JOHN ADAIR'S GRAVESTONE. John Adair (1732–1827) served in the North Carolina Militia during the Revolutionary War. This service earned him a land grant in western North Carolina (now East Tennessee).

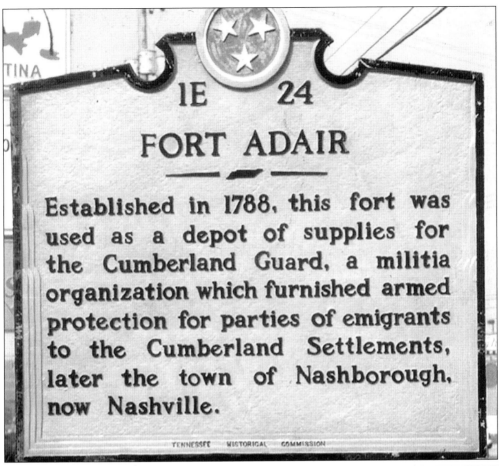

1E 24

FORT ADAIR

Established in 1788, this fort was used as a depot of supplies for the Cumberland Guard, a militia organization which furnished armed protection for parties of emigrants to the Cumberland Settlements, later the town of Nashborough, now Nashville.

TENNESSEE HISTORICAL COMMISSION

SITE OF FORT ADAIR. The state historic marker is placed near the site of Fort Adair on North Broadway, a busy thoroughfare, to give it visibility.

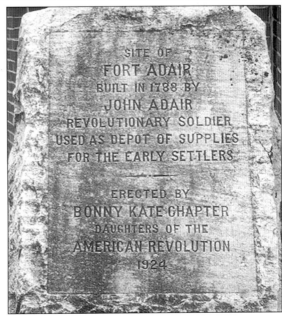

SITE OF
FORT ADAIR
BUILT IN 1788 BY
JOHN ADAIR
REVOLUTIONARY SOLDIER
USED AS DEPOT OF SUPPLIES
FOR THE EARLY SETTLERS

ERECTED BY
BONNY KATE CHAPTER
DAUGHTERS OF THE
AMERICAN REVOLUTION
1924

FORT ADAIR MONUMENT. The monument reads, "Site of Fort Adair, built in 1788 by John Adair, Revolutionary Soldier, Used as a Depot of Supplies for the Early Settlers. Erected by Bonny Kate Chapter, Daughters of the American Revolution, 1924."

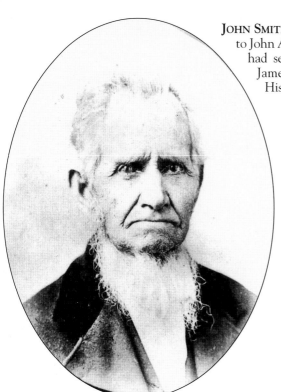

JOHN SMITH (1795–1883). John Smith was married to John Adair's granddaughter Mariah. The couple had seven daughters and two sons, including James Harvey Smith. (C.M. McClung Historical Collection, 200-001-275.)

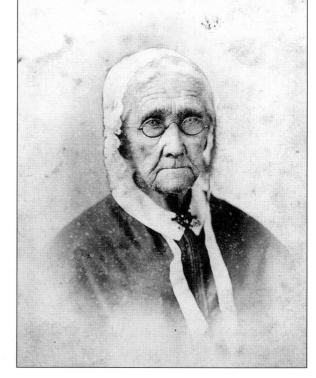

MARIAH ADAIR CHRISTIAN SMITH (1802–1883). John Smith's wife was the granddaughter of John Adair. Her father was the famous Col. Gilbert Christian of Sullivan County, a founder of Kingsport. (C.M. McClung Historical Collection, 200-109-013.)

JAMES HARVEY SMITH (1840–1932). Smith was the great-grandson of John Adair, who farmed in Smithwood throughout his long life. (C.M. McClung Historical Collection, 200-109-010.)

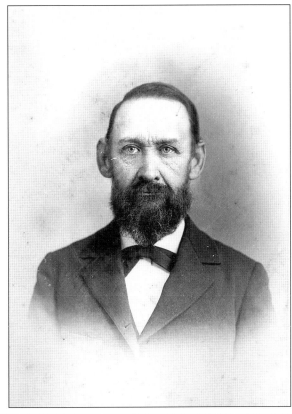

JOHN SMITH HOUSE FROM THE WEST (C. 1956). This house was built *c.* 1839 and was later occupied by John Smith's son, James Harvey Smith. Harvey Broome visited the house in his youth and remembered it fondly in his book *Out Under the Sky of the Great Smokies.* (C.M. McClung Historical Collection, 200-109-006.)

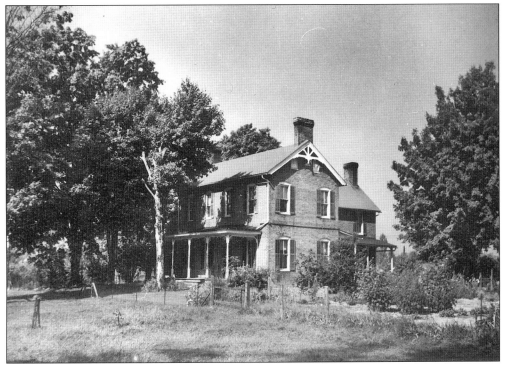

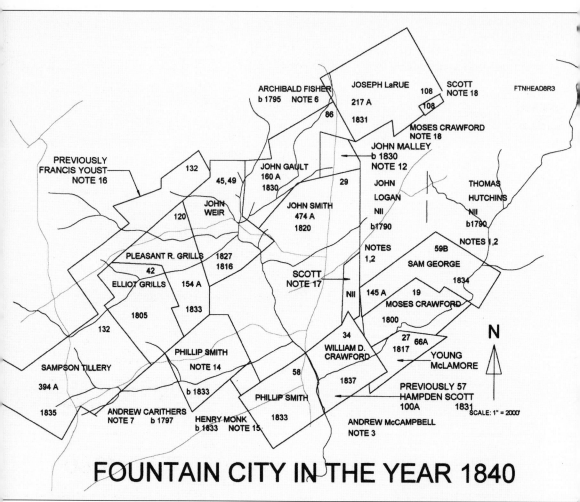

ARCHIBALD FISHER
b 1795 NOTE 6
86

JOSEPH LaRUE
217 A
1831
108

SCOTT
NOTE 18
108

FTNHEAD8R3

MOSES CRAWFORD
NOTE 18

JOHN MALLEY
b 1830
NOTE 12

PREVIOUSLY
FRANCIS YOUST
NOTE 16

132

45, 49

JOHN GAULT
160 A
1830

JOHN
WEIR

120

JOHN SMITH
474 A
1820

29

JOHN
LOGAN
Nll
b 1790

THOMAS
HUTCHINS
Nll
b 1790

NOTES
1,2

59B

SAM GEORGE

NOTES 1,2

PLEASANT R. GRILLS 1827
1816
42
ELLIOT GRILLS 154 A

1805 1833

132

SCOTT
NOTE 17

Nll 145 A 19

MOSES CRAWFORD

1800

1834

PHILLIP SMITH
NOTE 14

b 1833

58

34

WILLIAM D.
CRAWFORD

1837

27 66A
1817

YOUNG
McLAMORE

N

SAMPSON TILLERY

394 A

1835

ANDREW CARITHERS
NOTE 7 b 1797

HENRY MONK
b 1833 NOTE 15

PHILLIP SMITH

1833

ANDREW McCAMPBELL
NOTE 3

PREVIOUSLY 57
HAMPDEN SCOTT
100A 1831
SCALE: 1" = 2000'

FOUNTAIN CITY IN THE YEAR 1840

FOUNTAIN CITY IN 1840. This map shows the division of John Adair's original 640 acres in 1840. (From a book in preparation, *Maps of Grants and Early Land Owners in the Fountain City Area from 1788 to 1900*, by permission of the author, Jack E. Sterling.)

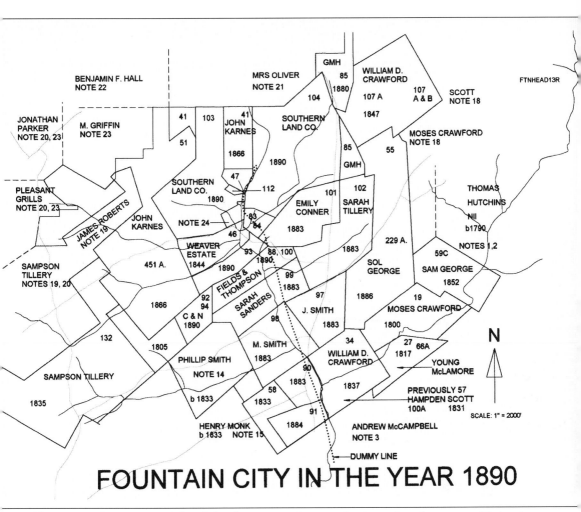

FTNHEAD13R

BENJAMIN F. HALL
NOTE 22

JONATHAN PARKER
NOTE 20, 23

M. GRIFFIN
NOTE 23

PLEASANT GRILLS
NOTE 20, 23

JAMES ROBERTS
NOTE 19

JOHN KARNES

SAMPSON TILLERY
NOTES 19, 20

SAMPSON TILLERY

1835

41 103 41 JOHN KARNES

51

1866

SOUTHERN LAND CO.
1890

NOTE 24

WEAVER ESTATE
1844

451 A.

1866

C & N
1890

132

1805

PHILLIP SMITH
NOTE 14

b 1833

HENRY MONK
b 1833 NOTE 15

47

112

83
84

46

93 88, 100
1890.

FIELDS & THOMPSON

SARAH SANDERS

92
94

95

M. SMITH
1883

58
1833

91

1884

1890

99
1883

97

J. SMITH

1883

90
1883

MRS OLIVER
NOTE 21

104

SOUTHERN LAND CO.

GMH
85
1880

101 102

EMILY CONNER

SARAH TILLERY

85
GMH

1883

SOL GEORGE

1886

34
1817

WILLIAM D. CRAWFORD

1837

ANDREW McCAMPBELL
NOTE 3

WILLIAM D. CRAWFORD

107 A

1847

55

229 A.

27
1800

66A

DUMMY LINE

GMH

107
A & B

SCOTT
NOTE 18

MOSES CRAWFORD
NOTE 18

THOMAS HUTCHINS
Nil
b1790
NOTES 1,2

59C

SAM GEORGE
1852

19

MOSES CRAWFORD

YOUNG McLAMORE

PREVIOUSLY 57
HAMPDEN SCOTT
100A 1831

N

SCALE: 1" = 2000'

FOUNTAIN CITY IN THE YEAR 1890

FOUNTAIN CITY IN 1890. Land development and an emphasis on the advantages of living in Fountain City resulted in the division of many original plats by 1890. (From a book in preparation, *Maps of Grants and Early Land Owners in the Fountain City Area from 1788 to 1900*, by permission of the author, Jack E. Sterling.)

15

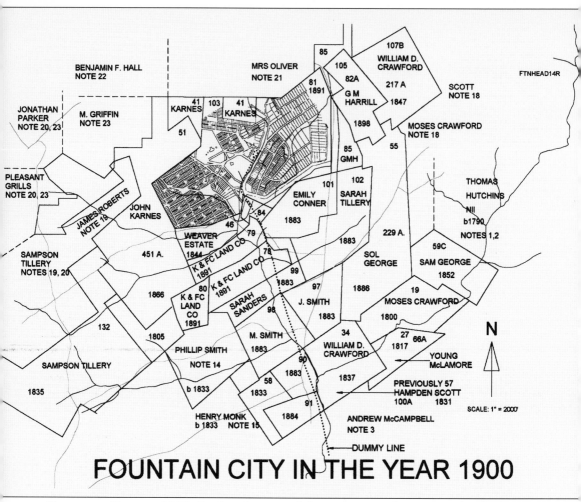

FOUNTAIN CITY IN THE YEAR 1900

FOUNTAIN CITY IN 1900. Further division of the property and extensive development in central Fountain City by the Knoxville and Fountain City Land Company is shown on this map. (From a book in preparation, *Maps of Grants and Early Land Owners in the Fountain City Area from 1788 to 1900*, by permission of the author, Jack E. Sterling.)

Two

FOUNTAIN CITY PARK

The 12-acre park was used for religious camp meetings as early as the 1830s. An announcement in the Knoxville Register *on September 10, 1857, reported, "Methodist Camp Meeting commences at Fountain Head Camp Ground tomorrow." Another such announcement appeared in the September 8, 1868* Register *announcing, "Arrangements for a camp meeting at Fountain Head completed. First gun will be fired Thursday night. A number of eating houses will be established. Rev. William Pearne in charge of the Knox Circuit will conduct it." On August 19, 1869, a reporter from the* Daily Press and Herald *visited the campground and gave an interesting account:*

> *The early morning services at the church were attracting people to their devotions. The church is a large frame building 60 x 100 feet painted white and therefore showing to an advantage amid the surrounding scenery.*
>
> *There are two services in the morning and one at 3 o'clock p.m., and the last at 'early candle light.' The meetings have been largely attended and great interest manifested. On Sunday last there were over 2000 persons in attendance. The average number of visitors since last Thursday, the opening day, has been about 1200.*

His glowing description continues with such phrases as these: "The meals cooked in the tents are simple but wholesome," "Water is obtained from the head of 1st Creek. It is famous the country over for the pure cold water," and "The intervals between the meetings are filled with rambles among the giant trees or lounging in their shade."

The same cool breezes, pure clear water, large oak trees, and the generally peaceful surrounds made the park an ideal place for reunions of Civil War veterans, including those surviving the Sultana Disaster. Many political debates, including one between brothers Robert L. Taylor (Democrat) and Alfred A. Taylor (Republican) in the 1886 "War of the Roses" gubernatorial campaign, were also held there.

By the early 1900s, the Knoxville Railway and Light Company owned the Dummy Line and the park and in 1926 proposed to develop the park by dividing it into lots, creating a residential subdivision. Judge John W. Green and attorney Ben Ogle contested the sale and, after lower court decisions, won a case before the Tennessee Supreme Court decreeing that "the petitioner should be enjoined from dismantling the park." It was thus saved for the enjoyment of future generations.

Today, family picnics in the park are routine and Fountain City Town Hall sponsors the Annual Memorial Day "Honor Fountain City Day" there. Fountain City Park continues to be a center of community activity.

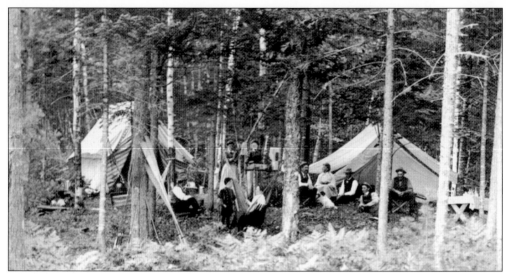

TYPICAL CAMPGROUND SCENE. Men, women, and children camped in large tents, one for the women and another for the men, for as much as a week-long camp meeting. They hauled food and enough cooking supplies to last a week in their wagons. (Betsey Creekmore Collection, used with permission.)

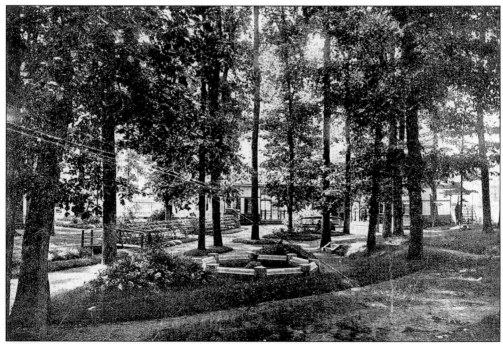

SCENE IN THE PARK BEHIND THE DUMMY LINE STATION. The open-air nature of the station affords easy access to the decorative pool, bountiful flowerbeds, large trees, and the flowing stream. (C.M. McClung Historical Collection.)

A NURSEMAID TENDS CHILDREN AT THE FOUNTAIN HEAD SPRING. Then, as now, wading in the cold spring water was an attraction for children. (Published by Monroe Howard.)

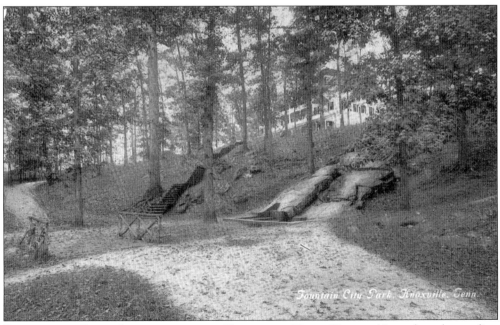

SPRING AND STEPS LEADING TO THE FOUNTAIN HEAD HOTEL. Note that the wading pool that is so much fun for children was not present in the early 1900s. (Published by S.H. Kress & Co.)

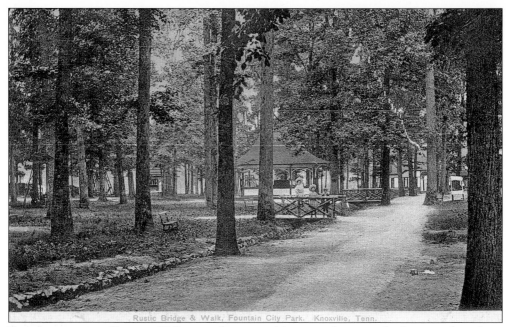

Rustic Bridge & Walk, Fountain City Park. Knoxville, Tenn.

BANDSTAND AND GAZEBO. Tall trees, flowers in bloom, and a rustic bridge appeal to these three children. (Published by Monroe Howard.)

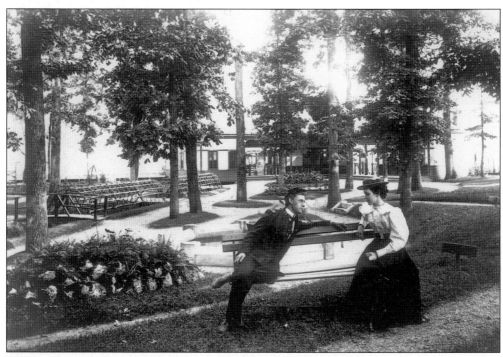

YOUNG COUPLE IN LOVE. The lake and park were excellent fun for courting young couples. Many Fountain City families remember the park in their youth and the fun time they had there. (C.M. McClung Historical Collection, GP-1157, undated.)

GAZEBO, BENCH, AND RUSTIC BRIDGE. This is an early, but exceedingly clear, image of the three subjects. The gazebo has been gone for years, but the Fountain City Lions Club and volunteers from the community built a replica in 1991. (University of Tennessee Special Collections.)

THE GRAND ARMY OF THE REPUBLIC. Union veterans of the Civil War met in the park on September 9, 1909. Similar reunions were held there often. (C.M. McClung Historical Collection, 200-134-012; courtesy of Dorothy Brooks.)

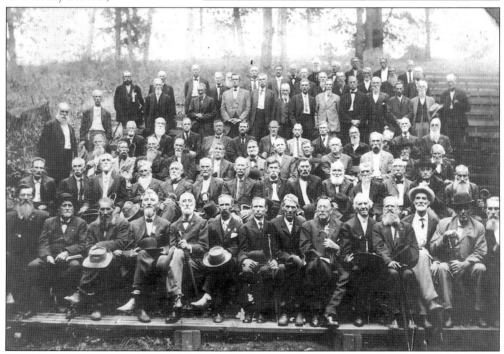

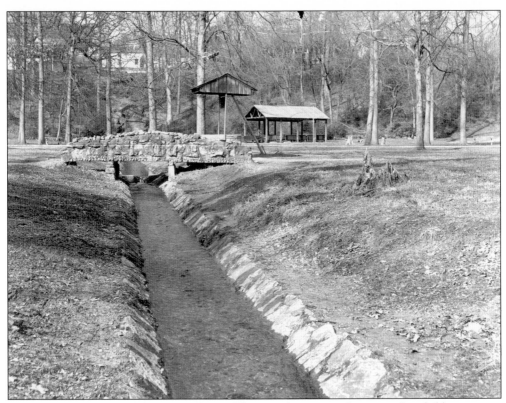

STREAM FLOWING THROUGH THE PARK. This is a favorite wading area for children; it was planned for their easy access.

VIEW OF THE PARK AND THE SLIDES AND SWINGS FOR CHILDREN. The Lions Club supervised the acquisition and maintenance of the slides, swings, and monkey bars.

Three
FOUNTAIN CITY LAKE

The years 1890 and 1891 were busy ones in Fountain City. Probably no other years in its history saw as many changes and new developments. The Knoxville and Fountain Head Land Company was responsible for much of the change. Perhaps the most visible new feature was the spectacular Fountain City Lake. F.G. Phillips, a prominent civil engineer, was hired to design a romantic heart-shaped lake with a walkway around it. White picket fences highlighted its innovative shape.

The area south of the Methodist Church was low and marshy, and First Creek flooded it during the rainy seasons, making it ideal for a lake and not much else. The several small springs in the lakebed and the large one on the western bank provided enough flow to maintain the lake level. The dirt removed in dredging the lake was used to embank it, but many years later the banks were lined with rock to make it more beautiful and to prevent washout. Some say the excess dirt from the excavation was hauled a few hundred yards east and piled there at the present-day site of the AmSouth Bank. The large pile of dirt resembled a Native American burial mound and generated many theories and fables among the teenaged boys.

The Fountain City Lions Club spearheaded a fund-raiser to completely refurbish the lake in 1985 and 1986. Both the state and federal government contributed funds for the grand undertaking. Photographs of the drained lake indicate the large amount of muck that had accumulated over many years. This time, most of the dirt and muck that was removed was hauled to Franklin Park and used to fill the miniature canyon the boys called "the Holler," the deep ravine between Balsam and Holbrook north of Kingwood Road. Children no longer had an imaginary movie set in which to play Tarzan or mimic their favorite cowboy actor.

The fountain on the island in the middle of the lake, symbolic of Fountain City's many springs, was also rebuilt in 1986. Although it is always beautiful, it is particularly spectacular when it is frozen in wintertime and becomes a giant icicle. Volunteer members of the Lions Club can be seen almost daily as they maintain both the park and the lake for the enjoyment of the community.

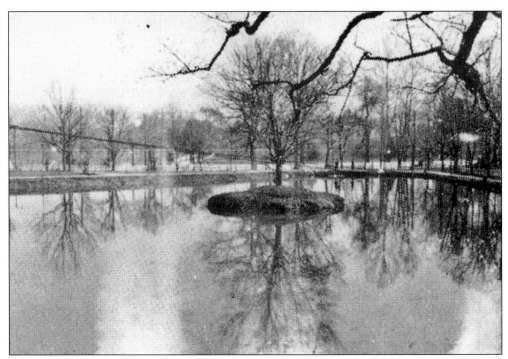

EARLIEST KNOWN PHOTOGRAPH OF THE LAKE (C. 1895). The lake probably appeared as it does in this photograph when it was first impounded in 1890.

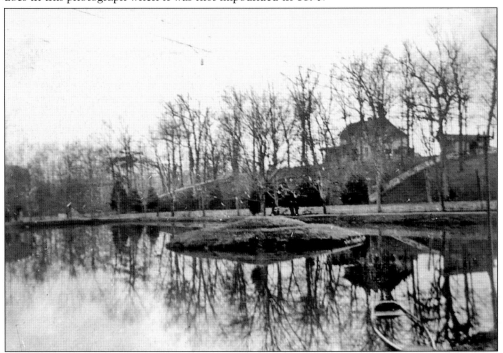

LAKE VIEW. Col. J.C. Woodward, a developer from Lexington, Kentucky, purchased 431 acres of land in 1890 at a cost of $159,600. He built for his son this home overlooking the lake and called it Lake View. (C.M. McClung Historical Collection, 200-214-140.)

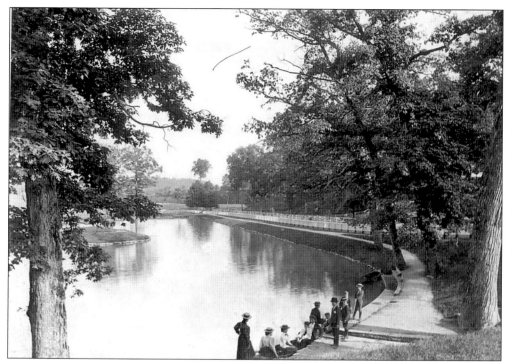

PHOTOGRAPH FROM AN EARLY TIME. The formally-dressed "Gay Nineties" visitors stand at the mouth of the stream flowing into the lake from the large spring, the major source of fresh water. The spring is located near the lake's northwest border. (University of Tennessee Special Collections.)

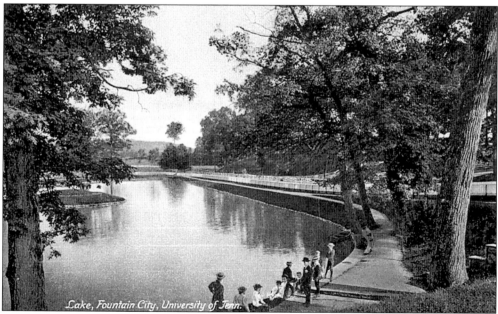

POSTCARD OF THE SAME SCENE. This colorized postcard is obviously adapted from the previous photograph. As with most cards at the time, it was printed in Germany. (Published by International Post Card Company.)

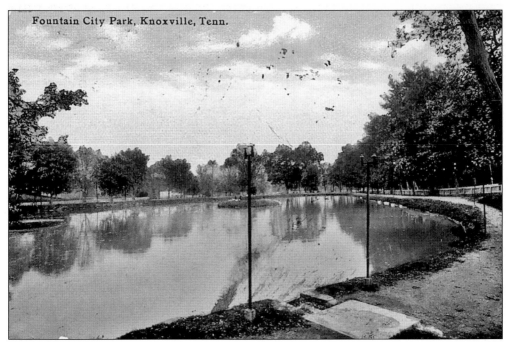

Fountain City Park, Knoxville, Tenn.

GRAVEL WALK AND PICKET FENCE. In the early 1900s, one of Knoxville's most fashionable neighborhoods, Park City, was in east Knoxville. A favorite Sunday afternoon diversion was taking your date from Park City on the Lake Ottossee Line, to the Dummy Line, then to picturesque Fountain City Lake for a stroll.

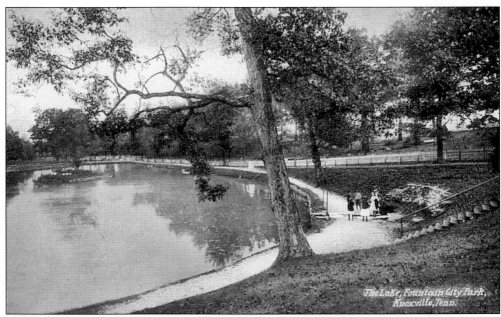

The Lake, Fountain City Park, Knoxville, Tenn.

CHILDREN AT THE SPRING. Note how the children are dressed in the attire worn early in the 20th century. (Published by Octochrome Post Card Company.)

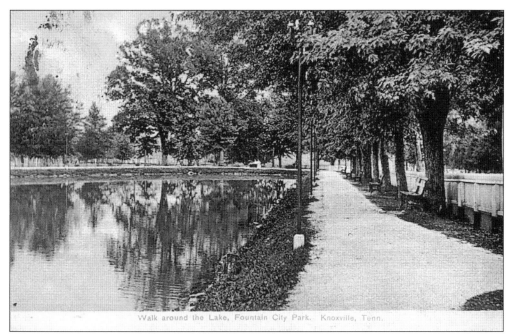

Walk around the Lake, Fountain City Park. Knoxville, Tenn.

SCENE AT THE APEX OF THE HEART-SHAPED LAKE. The apex of the heart was at the southwest end of the lake and is rarely seen in early photographs. It appears that the lake was lighted at night even at an early date. (Published by Monroe Howard Litho-Chrome.)

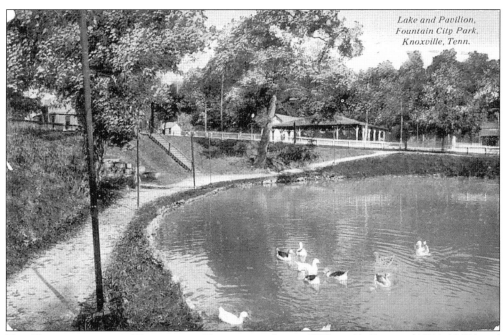

Lake and Pavilion,
Fountain City Park,
Knoxville, Tenn.

THE PAVILION AT THE NORTHWEST END OF THE LAKE. William E. Cooper (1876–1930) and Dossie Miller Cooper (1882–1968) operated a merry-go-round at the pavilion for several years. Note that the ducks were present as early as 1912, when this postcard was mailed. (Published by S.H. Kress & Company.)

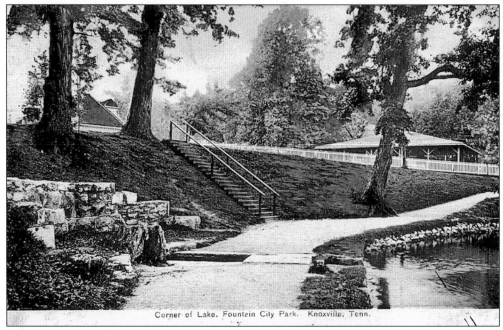

Corner of Lake, Fountain City Park, Knoxville, Tenn.

THE PAVILION AND AN UNIDENTIFIED BUILDING. This closer view of the pavilion also includes a house or fancy barn to the left, which we have been unable to identify in other photographs or postcards. (Published by Monroe Howard Litho-Chrome, postmarked 1908.)

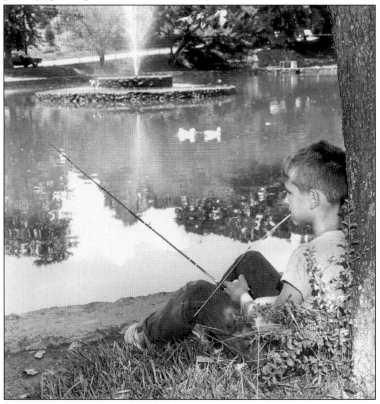

SERIOUS YOUNG FISHERMAN. In 1961, 10-year-old Eddie Scott, who lived on Fenwood Drive, did some serious fishing several times a week during the summer. Edwin M. Scott Jr. is now a fisheries biologist with the Tennessee Valley Authority at Norris, Tennessee, and lives in Fountain City. (Reprinted by permission of the *Knoxville News-Sentinel* Company.)

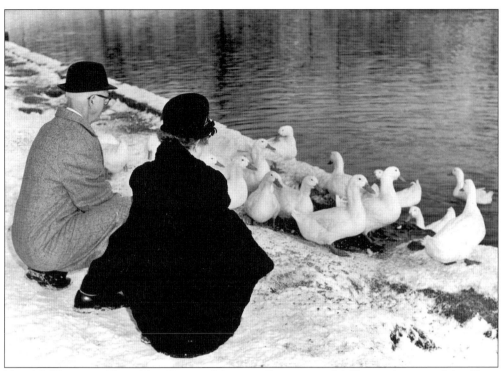

THE MCHARRISES FEED THE DUCKS. Margaret Zimmerman McHarris, director of the Knox County Animal Shelter at the time, and her husband, G.C. McHarris, feed the ducks during a winter storm in 1965. (Reprinted by permission of The *Knoxville News-Sentinel* Company.)

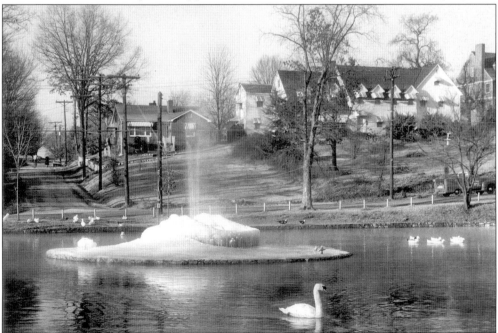

ICE ON THE FOUNTAIN. This swan seems oblivious to a winter ice storm in 1958. (Reprinted by permission of The *Knoxville News-Sentinel* Company.)

MCNEIL AND ALVAREZ REPAIR THE FOUNTAIN. Lon W. McNeil and Max M. Alvarez, Lions Club volunteers, are on their way to repair the fountain in this 1988 image. Nearly 20 years after this photograph was taken, they still volunteer at the lake and park. (Reprinted by permission of *The Knoxville News-Sentinel* Company.)

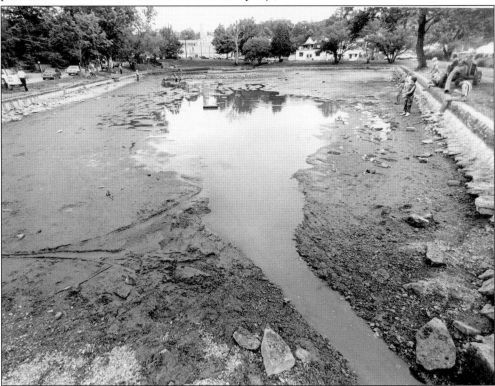

LAKE DRAINED FOR REFURBISHING. In 1985 and 1986, the lake was drained to remove the muck that builds up periodically. Using both state and federal grants, the lake and the retaining walls were completely refurbished. (Reprinted by permission of *The Knoxville News-Sentinel* Company.)

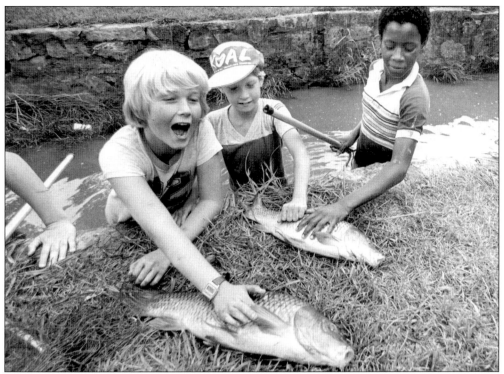

PROUD BOYS NET CARP. Reggie Foland, Jason Osborn, and Terry Cline had a field day netting carp when the lake was drained in 1985. (Reprinted by permission of *The Knoxville News-Sentinel* Company.)

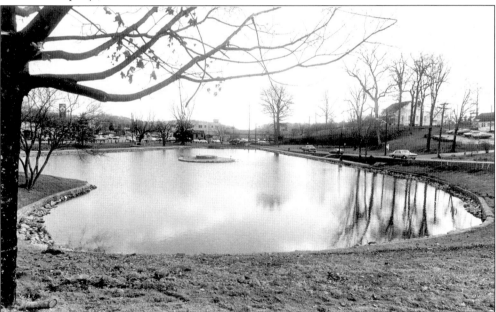

PRISTINE AGAIN AFTER MANY YEARS. This photograph, taken around the lake's 100th anniversary on December 23, 1985, shows the vast improvement in the general appearance of the lake after it was refurbished. (Reprinted by permission of *The Knoxville News-Sentinel* Company.)

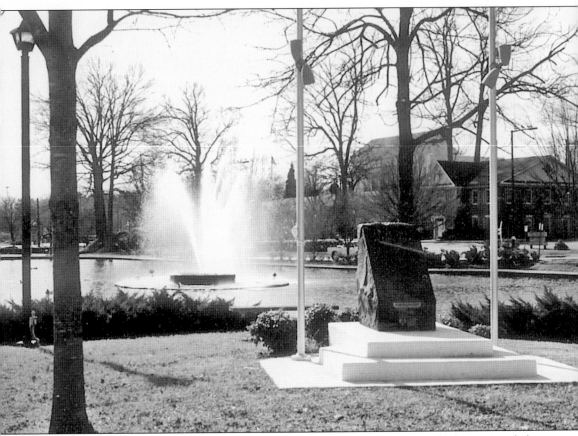

VETERANS MEMORIAL DEDICATED IN 1995. The Fountain City Lions Club sponsored this memorial to the veterans of all the wars. The inscription reads:

"Lest we forget. Dedicated in memory and honor
of all Fountain City veterans who served their country
and those who gave their lives that we may continue to enjoy freedom.
May the memory of their sacrifice forever endure."
Fountain City Lions Club, 1995

Four

THE FOUNTAIN
HEAD HOTEL

To continue to grow, Fountain City needed a destination place and the Fountain Head Improvement Company decided it would provide one—The Fountain Head Hotel and Resort. B.R. Strong, J.A. Adams, S.H. George, W.M. Epps, M.M. Nelson, E.H. Flenniken, James Anderson, Steve Condon, and J.C. Karnes formed a company and obtained a charter for the purpose. They sought a builder and an architect who would provide a measure of refinement, but mainly they wanted a hotel with vitality. Stephenson and Getaz had designed and were building the old Knox County Court House at the time and had a reputation for such projects; they were chosen to design and build the hotel. As a sideline they also ran the Stephenson-Getaz Manufacturing Company, which manufactured mantels, mostly of native hardwoods. Homes and public buildings required numerous mantels as most rooms had fireplaces. By 1891, the company had grown to $100,000 in capital stock and had 100 employees. Who could better provide the elegant woodwork for the hotel?

They designed a three-story, 40–50 room hotel and a number of cottages surrounding it. Unlike many summer resorts of the day, the design included two bathrooms on each floor with hot and cold water. Work was started in 1885 and completed in the spring of 1886.

There was both public and private transportation available from downtown, including Alf Hall's hack line, which ran from the end of the horse-drawn car line at Bluff Street (at the Broadway Shopping Center) to the hotel. Hacks were horse drawn "station wagons" and they were slow. Until the Dummy Line arrived in 1890, travel was possible, but it was slow and arduous over the macadamized Tazewell Turnpike. The Dummy Line was fun, fast, and usually reliable. Bookings for the $2 per day rooms increased dramatically with its arrival.

Another attraction was Miss Mary Donahue's dining room. She had served as the pastry chef for the Hotel Atkins downtown and she knew good dining. At 50¢ per meal, the rates were good, too. There was also the 6:30 concert by the Italian band each evening, a walk in the park or by the lake, and the dancing pavilion. The Fountain Head Hotel and Resort brought many visitors to Fountain City.

Fountain City
Hotel

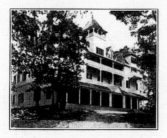

**25 Minutes Ride from Knoxville on
Fountain City Cars**

R. J. (DICK) YEARWOOD, Proprietor

Open All the Year Round

**Magnificent Springs and
Fine Park**

Rates $2.00 Per Day. Special Rates for Families

FOUNTAIN CITY HOTEL ADVERTISEMENT.
Evidently the name was changed, like
other Fountain Head names were, when the
post office renamed the area. This ad
appeared in the local papers many times.
(C.M. McClung Historical Collection,
#SPC 1995-30.)

**THE SOUTHWEST SIDE OF THE HOTEL
FROM THE PARK.** The lookout on the roof
must have afforded a spectacular view of
the park, the lake, and a panorama of
Grassy Valley.

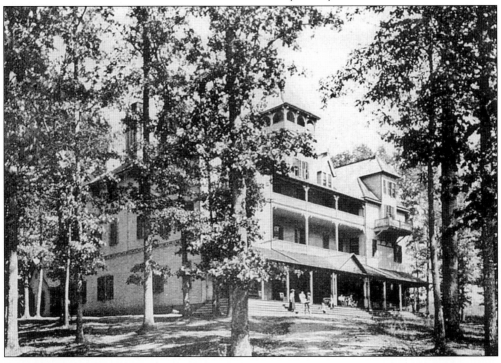

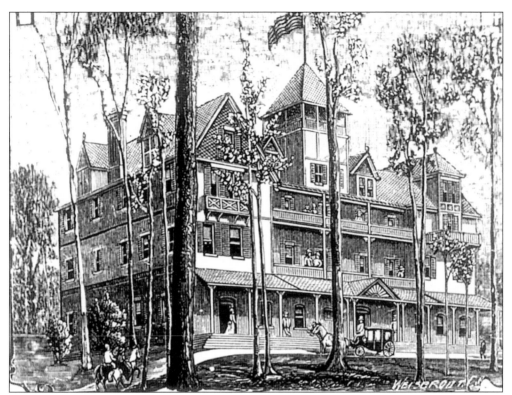

ETCHING OF THE HOTEL FROM ANDREW MORRISON'S 1891 BOOK. Note the horse-drawn carriage bringing guests, those arriving on horseback, and the guests on the spacious balconies overlooking the park. (Charles A. Reeves Jr.)

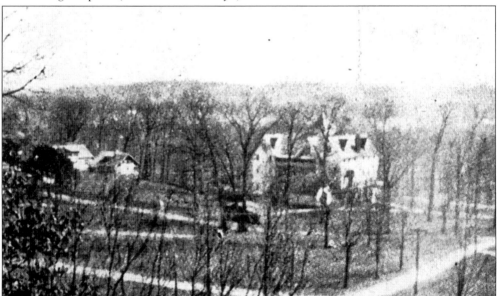

HOTEL VIEWED FROM HOLBROOK COLLEGE CAMPUS. Some historic houses are seen on the left on present-day Evergreen Lane. The heavily forested area of the park can also be seen. (Early Central High School *Sequoyah*.)

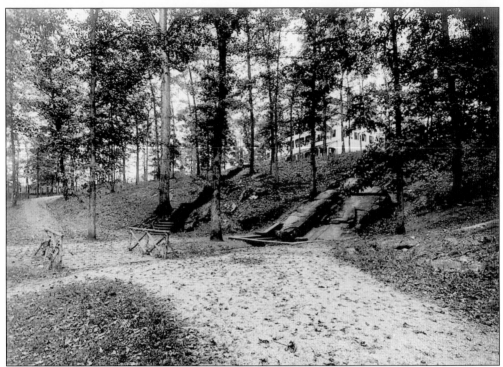

HOTEL VIEWED FROM THE PARK. The stairway leading down and across the rustic bridge to the Fountain Head Spring bespeaks the popularity of a walk in the park. One can imagine the Italian band marching down these steps each evening at 6:30 for the concert at the bandstand. (Thompson Historical Collection, used with permission.)

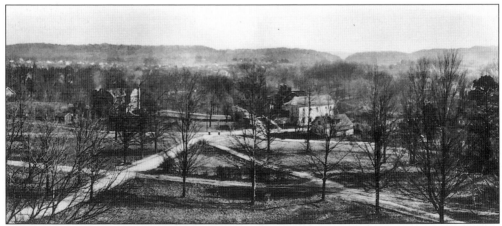

PANORAMIC VIEW FROM HOLBROOK COLLEGE SHOWING GRASSY VALLEY. Note the back of the hotel to the left, the two-story Odd Fellows Hall at the foot of Holbrook Campus, and in the distance to the right the Greenway Gap in Sharps Ridge.

Five

THE FOUNTAIN HEAD
RAILWAY (1890–1905)

The Fountain Head Improvement Company's imposing 40–50 room Fountain Head Hotel overlooking the park and the crystal clear spring had been in business four years now. A few prominent Knoxville families had already established summer homes in the suburb to escape the heat and humidity of downtown Knoxville. Many of those who commuted daily worked in downtown businesses, such as the railroad offices, stations, or shops or in the numerous textile factories. The five-mile trip by way of the old Tazewell-Jacksboro Turnpike took the wagons, buggies, carriages, and hacks several hours.

By late 1889, a group of local businessmen thought that a faster mode of transportation would be popular and might even prove to be a good investment. F.A.R. Scott, J.C. White, J.H. Cruze, John B. Neily, and S.H. George sought a charter for the Fountain Head Railway Company in November of that year. The first track was laid early in 1890 and the line opened for business by May 17, in a record time of only five months.

At first, inexperienced crews, balky early-stage locomotives, and a "green" track that was still quite bumpy resulted in frequent break downs about halfway to the final terminus at Fountain Head. A group of downtown entertainers, the Singleton Quartet, composed a ditty that became quite popular:

> Some folks say that the dummy won't run
> But I done seen what the dummy's done
> It left Fountain City at half past one
> And it got into Knoxville at settin' of sun.

The Dummy Line brought large numbers of day visitors to the hotel and resort. It also carried a considerable amount of freight, including the brick to build the Holbrook College buildings. The brickyard was at the site where McCampbell Elementary School was later built and directly on the route. Truly, the Dummy Line helped Fountain City grow in population and economy.

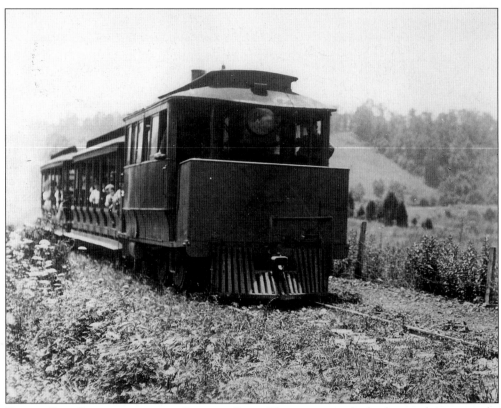

DUMMY LINE LOCOMOTIVE WITH SUMMER CARS. The scenery in the background appears to be Sharps Ridge near Greenway. (Calvin McClung Historical Collection, used with permission.)

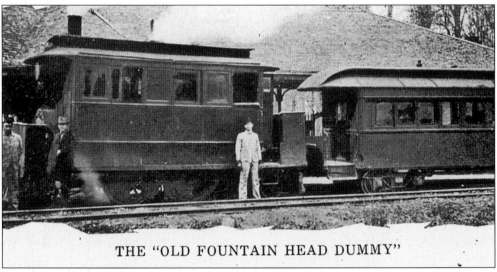

THE "OLD FOUNTAIN HEAD DUMMY"

LOCOMOTIVE AND WINTER CAR AT THE FOUNTAIN HEAD STATION. Since the steam engine was enclosed in a rectangular box to avoid "spooking" horses, it was called a "dummy" engine. The cowling obviously dampened some of the noise of hissing steam and churning drive wheels. (Walter M. Taylor Collection.)

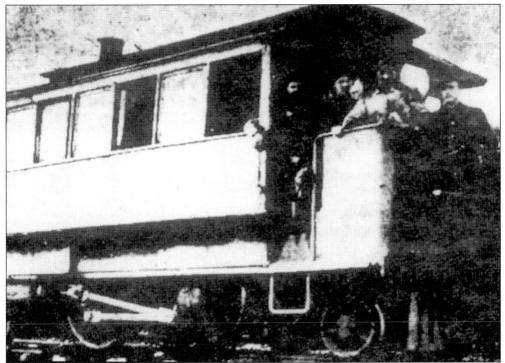

LOCOMOTIVE (2-4-2T) AND CREW. The crew members are, from left to right, Fred Hall, fireman; Ed Hall, engineer; Ross Hall (a cousin to Fred and Ed Hall but not a crewman); and Theodore Donaldson, the watchman.

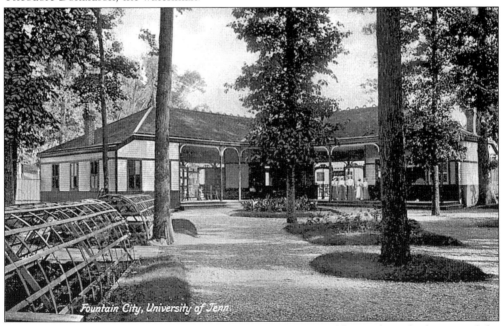

FOUNTAIN HEAD STATION FROM THE REAR. Passengers could exit through the rear of the open-air station into the beautiful park. Note the cold frames indicating horticulture experiments were underway. (Published by International Post Card Company.)

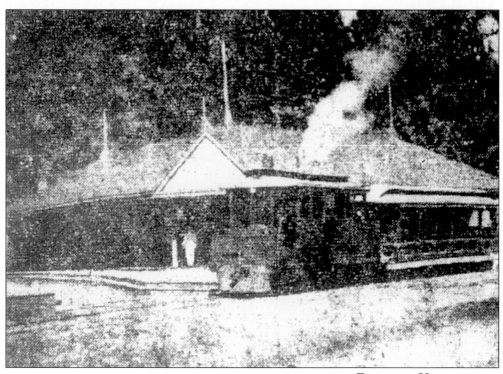

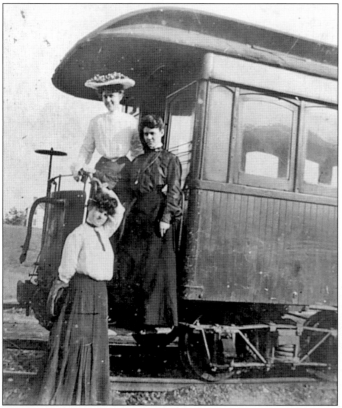

FOUNTAIN HEAD STATION FROM THE FRONT. The train is headed south toward Knoxville, a trip of 5.25 miles requiring about 25 minutes. (A co-author of this book has been seeking a better image of this for many years. There were three different locomotives and this may be the only photograph of the third one.)

THE ORNDORFF SISTERS BOARD THE DUMMY LINE. Maud Orndorff (standing at the foot of the steps) and her sisters board the Dummy in dress attire. (C.M. McClung Historical Collection, 200-90-4; courtesy of Kenneth and Kathy Cloninger.)

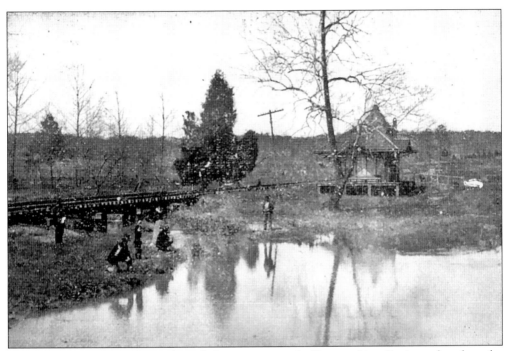

GREENWAY STATION. This is the only known image of a Dummy Line Station other than the Fountain Head Station. It was located where White's Creek enters First Creek. (Ronald R. Allen Collection.)

PASSENGERS WAITING TO BOARD. This rare image was found in an early Central High School *Sequoyah* yearbook. This shows a large number of men and women ready to board the Dummy, which received up to 10,000 fares each day.

✦ 1896 ✦
Fountain Head Railroad Co.
No. 440

Pass *Mr J. K. Holloway, T. FK P A*

Cumberland River Route,

Until December 31, Unless Otherwise Ordered.

Not Good Unless Countersigned by
Robert T. Baker.

L. P. Kents
General Manager.

Robt T Baker
Superintendent.

1896 FOUNTAIN HEAD RAILROAD COMPANY PASS, FRONT AND BACK. Officials of other railroads, newspaper people, family members of the crews, and others received a free pass. Those who owned a pass obviously had an economic advantage, which sometimes extended to free fares on other trains. (J.C. Tumblin Collection.)

CONDITIONS.

This ticket is issued and given only on condition that the person receiving it assumes all risk of accident, and expressly agrees that the Company is not liable (under any circumstances) for any injury to the person, or loss of, or damage to, the baggage of the person using it.

If presented by any other person than the individual named hereon, the Conductor will take up this ticket and COLLECT FARE.

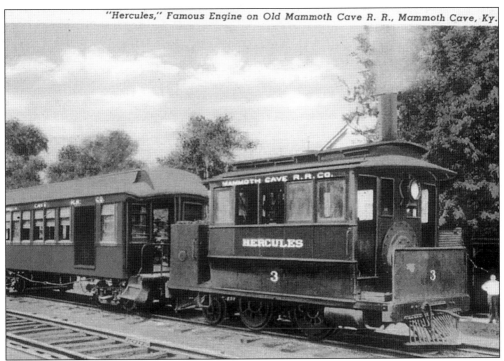

"Hercules," Famous Engine on Old Mammoth Cave R. R., Mammoth Cave, Ky.

MAMMOTH CAVE'S FAMOUS "HERCULES." This Baldwin 0-4-2T, used at Mammoth Cave, Kentucky, was similar to the Fountain Head locomotives and reveals the probable boiler placement.

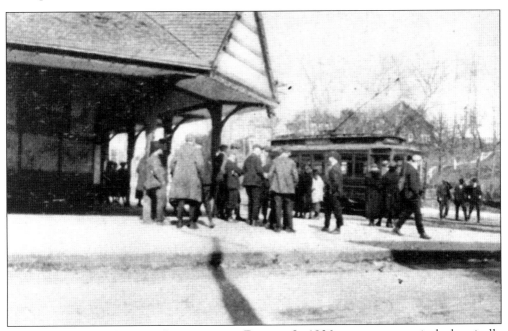

ELECTRIC TROLLEY SERVICE SUCCEEDS THE DUMMY. In 1906, a more economical, electrically powered trolley replaced the Dummy. Note the men and women in business attire on their way to work in the wholesale houses, railroads, or retail outlets downtown. Many commuted daily.

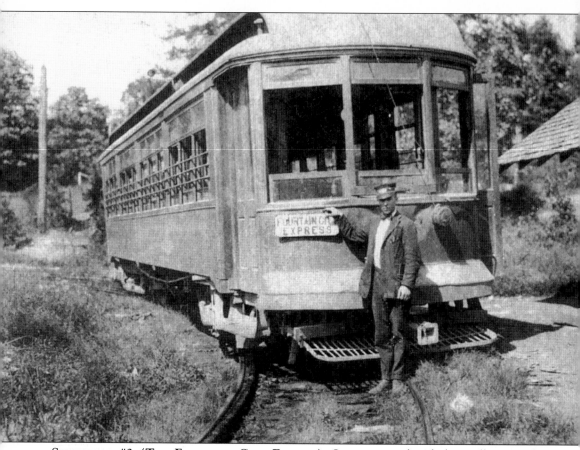

STREETCAR #3 (THE FOUNTAIN CITY EXPRESS). Streetcars replaced the trolleys on the Fountain City Route in 1920. The motorman is H.R.G. (Gip) McCoy and the car is a 90-101 series car. The loop in the track could be on the Fountain City line or in Lyons View at Lakeshore, as the route ran between the two locations. The shed does not appear in other early Fountain City photographs, so it may have been in Lyons View. (Betty McCoy Warwick Collection, used with permission.)

Six

OUR SCHOOLS

Early in its history, the educational system in Fountain City received a boost from an unexpected source. The Fountain City Land Company thought that by establishing a college and bringing numbers of students to the campus they would help the business community. They contacted Holbrook College, which had schools in both Indiana and Ohio. When an agent for Holbrook came to talk with the officials of the Land Company in 1892, he was so pleased with the offer made by them that he accepted it and chose a site for the school. The site was on the hill overlooking the park and the businesses in central Fountain City. By April 1893, a contract for $41,800 was given to a local firm, W.H. Dawn and Company. They were engaged to build three large three-story brick buildings, two wooden dormitories for boys on the west side of the school, and the president's home to the east. The Fountain Head Hotel was used as a girl's dormitory, apparently only during the time of the year when it was not used as a resort hotel.

The school opened on September 4, 1893, with an enrollment of more than 100 students. There were nine departments, including a normal college to train those who wanted to become teachers, a business college, a school of art, a music conservatory, and a military department.

Holbrook College had many distinguished graduates—E.E. Patton (Class of 1900) became the principal at Central High School and mayor of Knoxville, and Hassie K. Gresham (Class of 1902) was the principal of Central High School from 1919 to 1947 and saw the enrollment increase from 192 when she began her career to 1,500 when she retired. The quality of education at Holbrook and later at Central High School, under the influence of those two graduates of the school and their superb faculties, set a tone for Central's so-called "feeder schools." Smithwood Elementary had preceded them, having begun on land donated from the Smith estate in the late 1880s. Fountain City Elementary had its roots in the Odd Fellows Hall in 1902 where Miss Cassie Cox taught grades one through three. Shannondale Elementary was built in 1956 and Sterchi Elementary in 1959.

Fountain City has been very fortunate in the quality of its educational system from the 1800s to today.

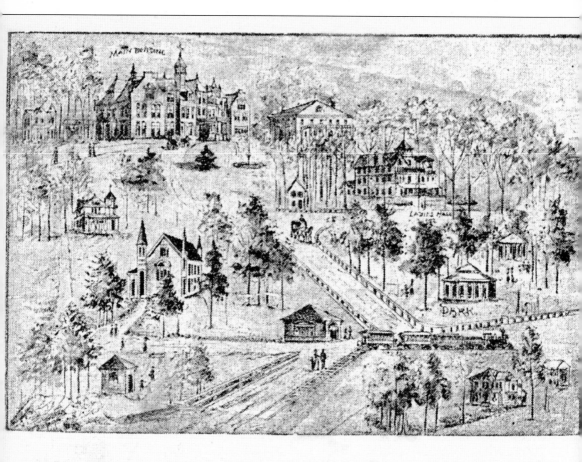

Holbrook Normal College,

FOUNTAIN CITY, KNOXVILLE, TENN.
. . SUBURB OF . .

ETCHING FROM HOLBROOK COLLEGE ENVELOPE. This may be the earliest known image of central Fountain City. The size of the buildings indicates some artistic license, but the location of the college buildings, hotel, and the second building of the Methodist Church seem accurate.

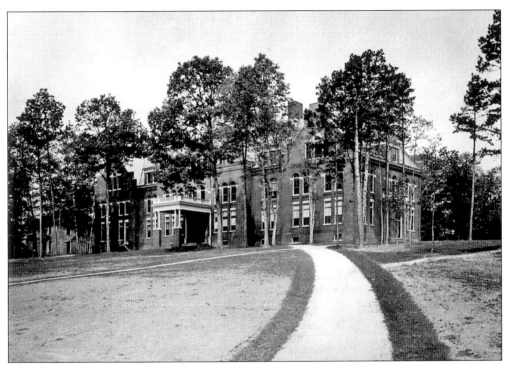

FIRST HOLBROOK COLLEGE BUILDING. Note the portico awaiting the arrival of guests and parents visiting the school on horseback or buggy. The first class of 100 students arrived in September 1893. The building burned in 1900. (University of Tennessee Special Collections.)

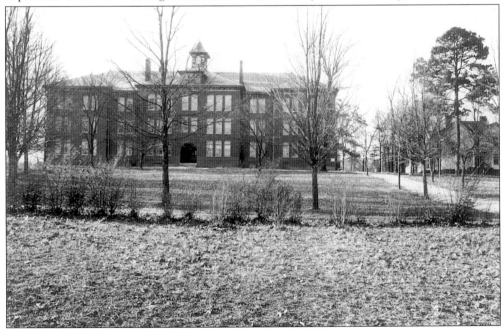

SECOND HOLBROOK COLLEGE BUILDING. After the first building burned, it was rebuilt and soon bought by the Tennessee Baptist Association. By 1906, it was sold to Knox County for use as a high school. (Thompson Historic Photographs, used with permission.)

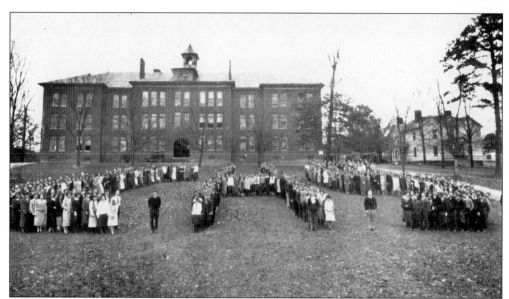

CENTRAL HIGH SCHOOL, 1925. The Central High School students standing in front of the former Holbrook College Main Building are forming a "CHS." The student body numbered 192 when Hassie K. Gresham became principal in 1919. (Central High School *Sequoyah*, 1925.)

GRESHAM HALL, CENTRAL HIGH SCHOOL. One of the buildings on the Central High School campus is pictured above. (Central High School *Sequoyah*, 1925.)

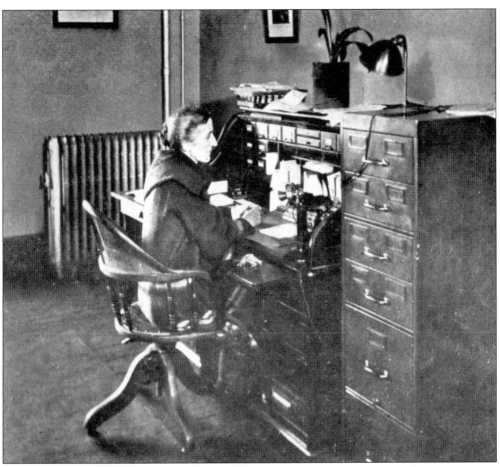

PRINCIPAL GRESHAM AT HER DESK.
Miss Gresham, a native of
Jonesborough, Tennessee, was
principal of Central High School from
1919 to 1947. She was recognized
widely as the epitome of leadership in
education. (Central High School
Sequoyah, 1925.)

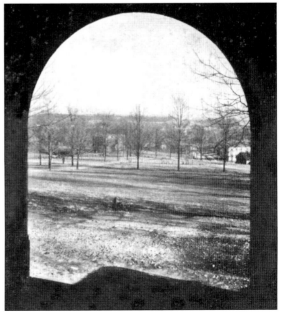

**VIEW DOWN HIGH SCHOOL HILL
TOWARD CENTRAL FOUNTAIN CITY.**
The 13-acre campus has beautiful trees
and shrubs. From its 1,100 foot
elevation, the hill offered a spectacular
view of Fountain City Park in the
foreground and the Great Smoky
Mountains in the distance. (Central
High School *Sequoyah,* 1925.)

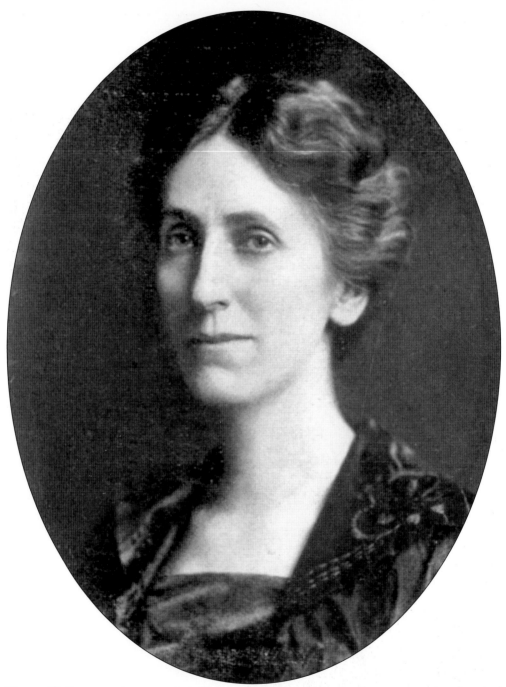

HASSIE K. GRESHAM (1877–1970). This 1925 portrait of Miss Gresham conveys her dignified but commanding presence, befitting a descendant of the founders of Gresham College in London, England. Her students found her to be strict but always fair. (Central High School *Sequoyah*, 1925.)

VIEW FROM HOTEL AVENUE LOOKING UP HIGH SCHOOL HILL. The spacious campus and beautiful trees were conducive to the learning process. Many students had lunch on the lawn in the spring and fall. (Central High School *Sequoyah*, 1925.)

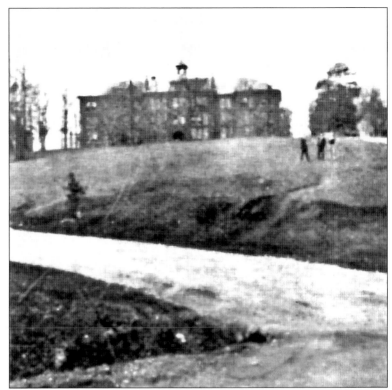

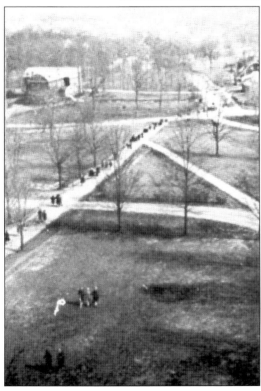

VIEW FROM THE SCHOOL LOOKING TOWARD PRESENT DAY BROADWAY. Note the wide walkways, the rear view of the Fountain Head Hotel to the left, and the Odd Fellows Hall to the right. (Central High School *Sequoyah*, 1925.)

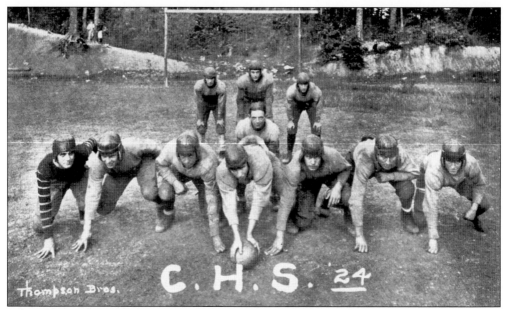

THE 1924 FOOTBALL TEAM. The team was coached by Victor Campbell and, because of a series of injuries, had one of its worst seasons (4 wins, 4 losses, and 3 ties) in 1924. Senior Roy (Rabbit) Acuff is the left end. (Central High School *Sequoyah*, 1924.)

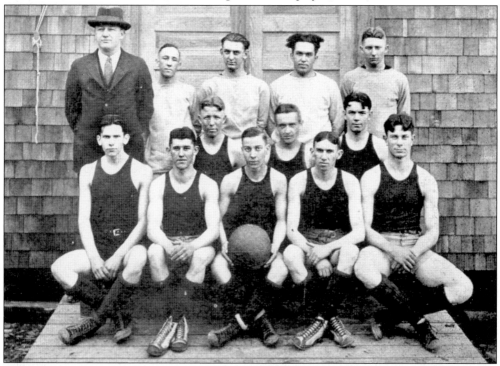

THE 1924 BASKETBALL TEAM. Coached by the legendary Franklin "Weenie" Wininger, the team starred "Bull" Briscoe and "Lucky" Acuff as guards. It seems Roy Acuff had several nicknames years before he became the "King of Country Music." (Central High School *Sequoyah*, 1924.)

52

ROY ACUFF IN BASKETBALL UNIFORM. Acuff earned 12 letters in three sports during his years at Central, a record yet to be equaled. (Central High School *Sequoyah*, 1924.)

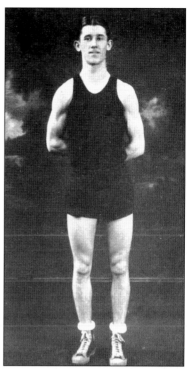

THE 1924 BASEBALL TEAM. Roy Acuff is pictured in the first row, second from the left. (Central High School *Sequoyah*, 1924.)

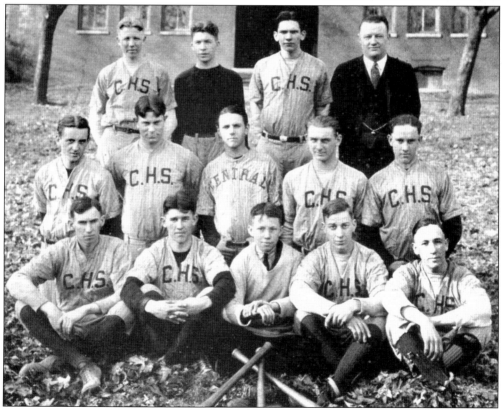

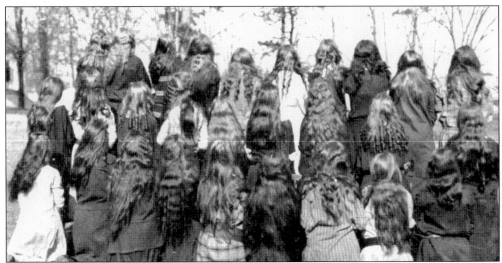

THE SAMSON CLUB. Central High students exhibit their sense of humor. The club's motto was "In length there is strength." (Central High School *Sequoyah*, 1925.)

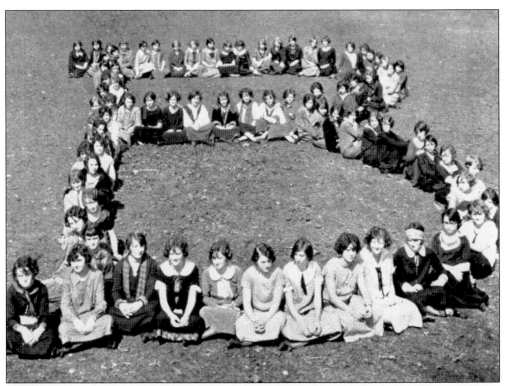

THE BOBBER'S UNION. Not to be outdone, another group of students formed the Bobber's Union and wore a much different hairstyle. (Central High School *Sequoyah*, 1925.)

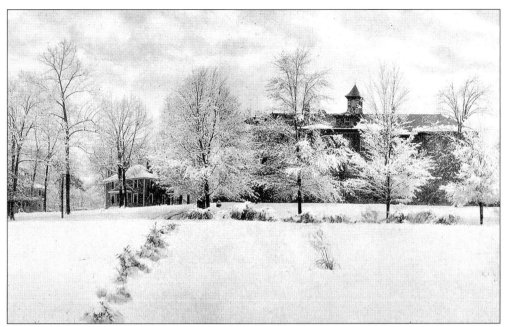

OLD CENTRAL HIGH SCHOOL IN THE SNOW. This is the famous snow scene that so many Central High School graduates treasure. (M.L. Brickey Collection.)

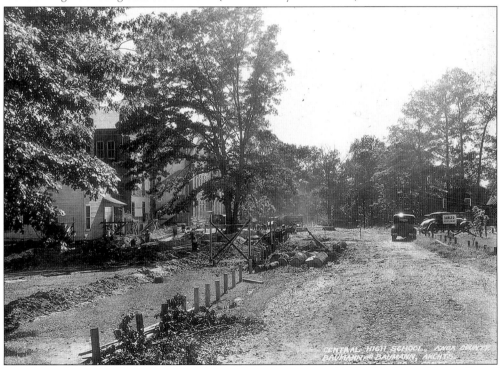

THE NEW CENTRAL HIGH SCHOOL UNDER CONSTRUCTION, 1931. The Knox County Board of Education approved a new, much larger school in 1931, with Baumann and Baumann, the architects, and V.L. Nicholson, the contractor. George W. Reagan, then early in his career, was the supervisor. Site preparation has just begun in this photo. (William H. Reagan Collection.)

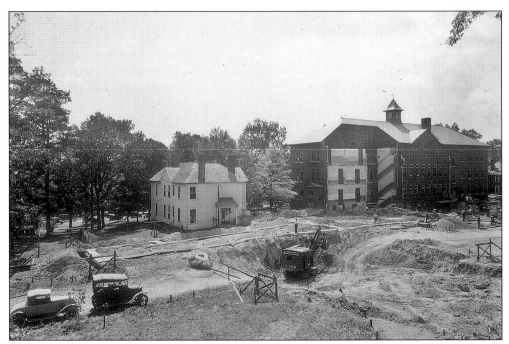

EXCAVATION FOR THE NEW CENTRAL HIGH SCHOOL. Note the vintage earth-moving equipment and 1930s automobiles. (William H. Reagan Collection.)

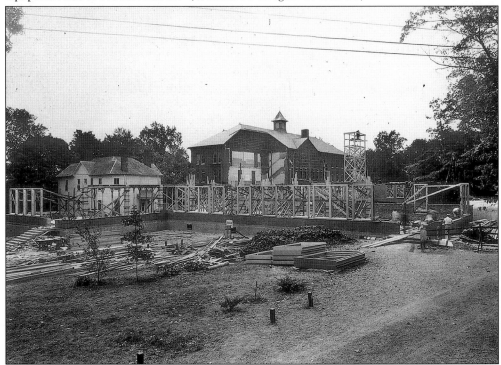

EARLY FRAMING UNDERWAY. The house in this scene may be the former home of the Holbrook College president. The Rev. Neill Acuff, Roy's father and minister at First Baptist Church of Fountain City, lived there in the 1920s. (William H. Reagan Collection.)

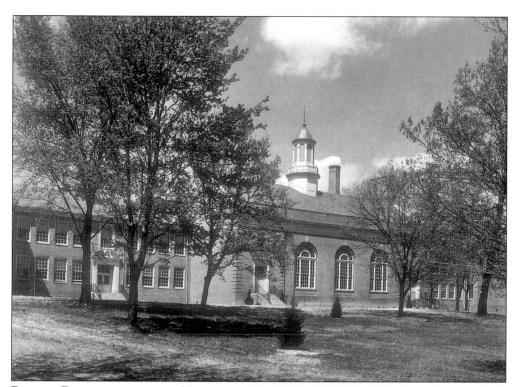

PREMIER PHOTOGRAPH OF THE NEW
CENTRAL HIGH SCHOOL. Note how
the cupola lends elegance to the
architectural design. (William H.
Reagan Collection.)

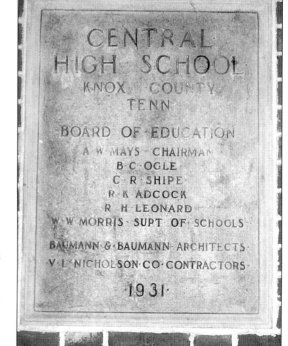

MARBLE PLAQUE IN ENTRYWAY OF THE
NEW SCHOOL. The chairman of the
Board of Education was A.W. Mays and
the superintendent of schools was W.W.
Morris when the new school opened.
The plaque remains at the site, which
now houses Gresham Middle School.

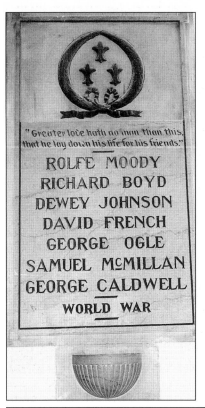

PLAQUE HONORING WORLD WAR I MILITARY HEROES. Miss Gresham endearingly called her students who served in the nation's wars "My Boys." These are the Central High School graduates who lost their lives in World War I.

CENTRAL HIGH SCHOOL ANNEX. When the new Fountain City Grammar School was built in 1931, a covered walkway was added to the old building and it was used as the annex to the adjoining Central High School, as shown in this 1967 photograph. (Reprinted by permission of *The Knoxville News-Sentinel* Company.)

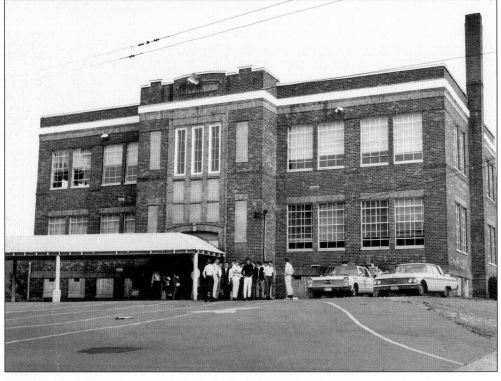

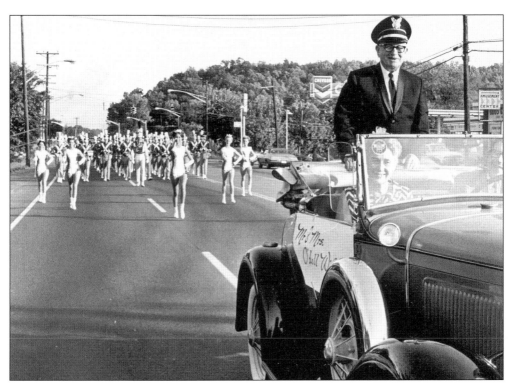

O'DELL WILLIS PARADE. O'Dell Willis (1905–1984) and his wife, Hazel Bowling Willis, ride in the 1971 parade that climaxed "O'Dell Willis Week," which honored him at his retirement. He became the Central High School band director in 1938 with 38 band members and grew the band to over 100 members. (Reprinted by permission of *The Knoxville News-Sentinel* Company.)

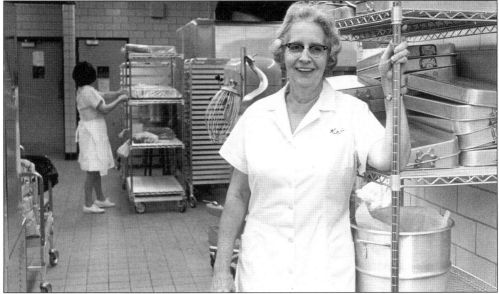

CAFETERIA MANAGER MARY B. HUNTER. Those who were students at Central High in the 1940s and 1950s will remember Mary B. Hunter for her smile, her menus, and especially for her meat salad sandwiches. (Reprinted by permission of *The Knoxville News-Sentinel* Company.)

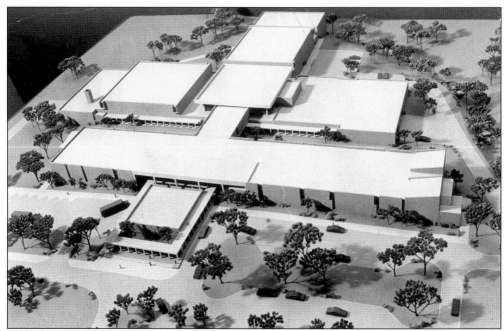

NEW CENTRAL HIGH SCHOOL COMPLEX. When the student body outgrew the 1931 building, this new state-of-the-art complex was built in 1971 at a cost of $6 million. (Reprinted by permission of *The Knoxville News-Sentinel* Company.)

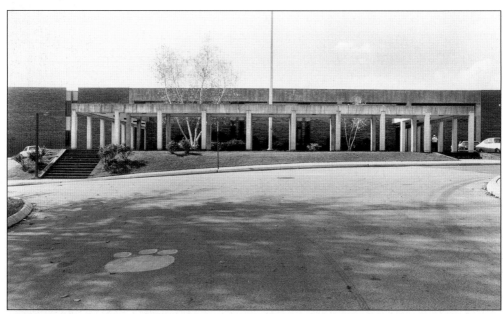

ATTRACTIVE LOGGIA GREETS STUDENTS, PARENTS, AND GUESTS. The loggia is both attractive and functional and lends a special touch to the new school. (Reprinted by permission of *The Knoxville News-Sentinel* Company.)

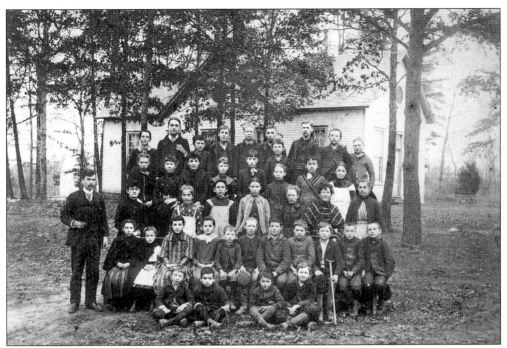

SMITHWOOD GRAMMAR SCHOOL (1889). Built on land given by the John Smith estate in the 1880s, Smithwood School was the first school in Fountain City north of Greenway. (C.M. McClung Historical Collection, 200-001-181.)

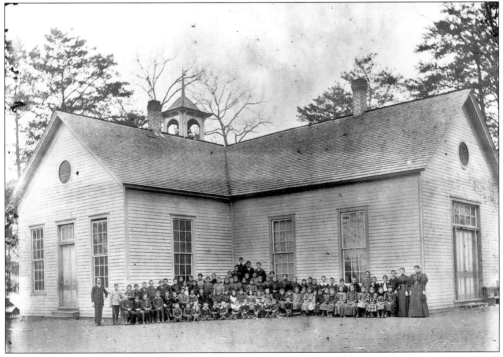

SMITHWOOD GRAMMAR SCHOOL (1895). This two-room building with a cupola and bell accommodated 50 boys and girls of all ages. (C.M. McClung Historical Collection, GP-787.)

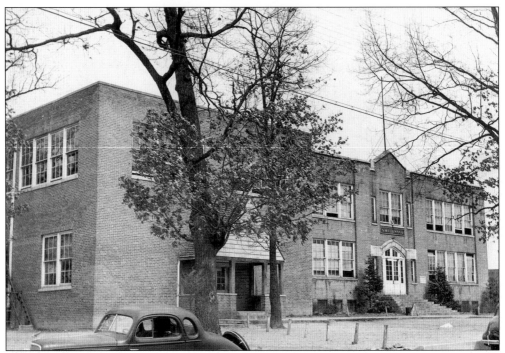

SMITHWOOD GRAMMAR SCHOOL. The right portion of the school building was constructed in 1915 and the addition on the left was built in 1928. (Reprinted by permission of *The Knoxville News-Sentinel* Company.)

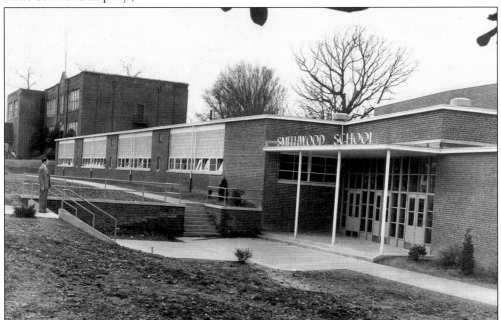

SMITHWOOD GRAMMAR SCHOOL. After this new building was built in 1950, there were 15 classrooms, an auditorium/gymnasium, cafeteria, clinic, and other convenience features. The addition was planned before World War II but was delayed by materials shortages. (Reprinted by permission of *The Knoxville News-Sentinel* Company.)

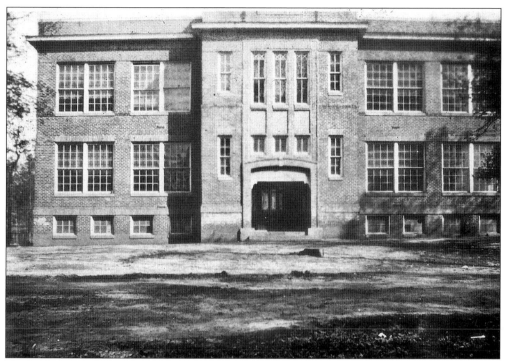

FOUNTAIN CITY ELEMENTARY SCHOOL. Built in 1917–1918 on the campus of Central High School, this building later became the annex to the high school. (Evelyn G. Kirby Collection, used with permission.)

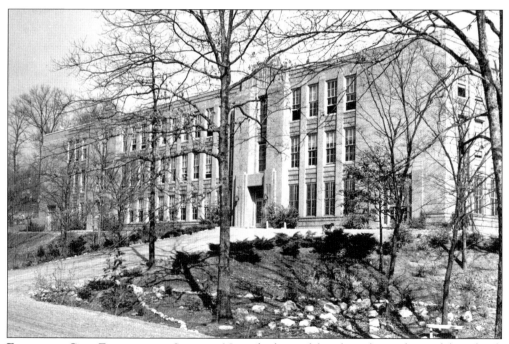

FOUNTAIN CITY ELEMENTARY SCHOOL. Note the beautiful rock garden in front of the school. (Ruth Ford Wallace Collection.)

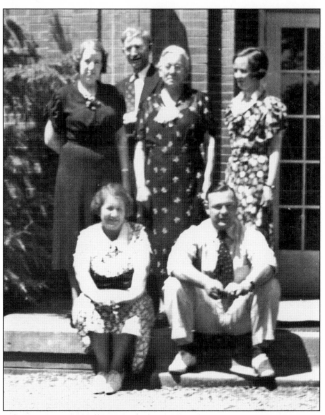

FOUNTAIN CITY ELEMENTARY SCHOOL PRINCIPAL AND TEACHERS. Anna Lowe was the principal of the school from 1925 to 1946. The following are pictured from left to right in this 1938 photograph: (seated) Jessie Ferguson and Charles Lee Graves; (standing) Floy Steiner, W.A. Bell, Anna Lowe, and Hester Freeman. (Ruth Ford Wallace Collection.)

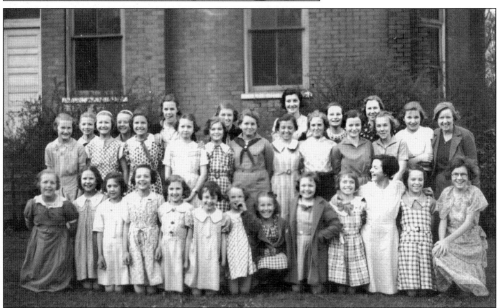

TROOP 17, GIRL SCOUTS OF AMERICA. Most of the Girl Scouts in this 1936 photograph were students at Fountain City Elementary School. They met at the Fountain City Methodist Church under the leadership of Mrs. I.V. Ragsdale and Sarah Vise (Raby). Ruth Wallace, Fountain City historian, is one of the scouts. (Ruth Ford Wallace Collection.)

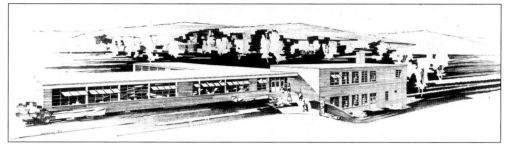

SHANNONDALE ELEMENTARY SCHOOL. This school was built in 1956 to serve the students who formerly attended Smithwood School and those in new subdivisions around Tazewell Pike. (Reprinted by permission of *The Knoxville News-Sentinel* Company.)

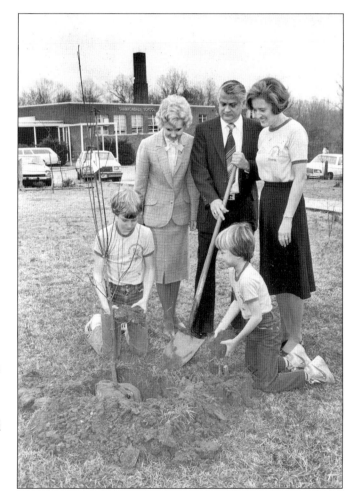

SHANNONDALE ELEMENTARY SCHOOL TREE PLANTING. The following people, from left to right, participated in the 1982 tree planting: (front row) Brad Neal and Chad Oaks; (back row) Mrs. Raymond Evans, Councilman Jack Sharp, and Mrs. Madeline Redmond (principal). (Reprinted by permission of *The Knoxville News-Sentinel* Company.)

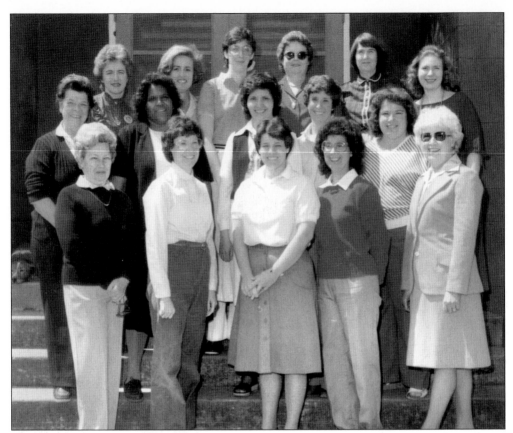

SHANNONDALE ELEMENTARY SCHOOL FACULTY. The 1982–1983 principal and faculty of Shannondale School are shown in this photograph. Mrs. Emma Fox, principal, is at the far right of the front row. (Shannondale Elementary School Files.)

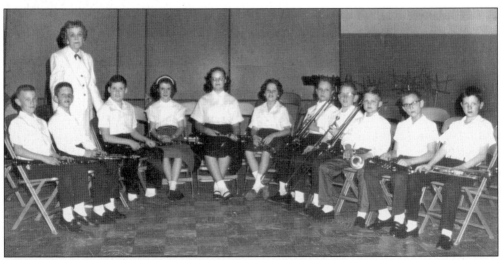

SHANNONDALE ELEMENTARY SCHOOL BAND. Eva Hagler, sister of Fountain City historian Nannie L. Hicks, is the music teacher pictured above. (Shannondale Elementary School files.)

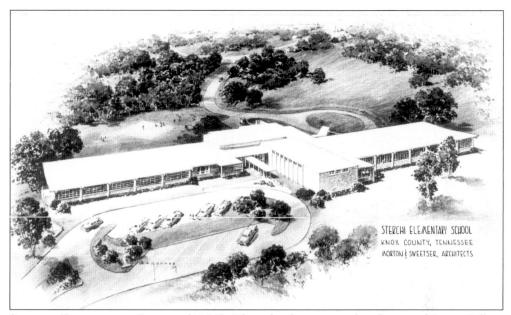

STERCHI ELEMENTARY SCHOOL (1959). The school was named in honor of James Gilbert Sterchi (1867–1932), who built a chain of 60 furniture stores throughout the South. His widow donated the land for Sterchi School. (Reprinted by permission of *The Knoxville News-Sentinel* Company.)

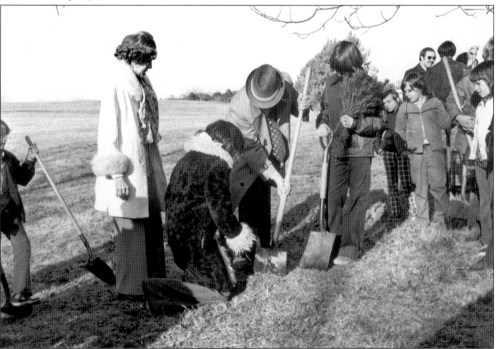

STERCHI ELEMENTARY SCHOOL TREE PLANTING. The following participants in this 1975 tree planting are pictured from left to right: Jean Freund; Kim Clark (kneeling); Dr. Roy Wallace, superintendent of schools; and Donnie Beeler. (Reprinted by permission of *The Knoxville News-Sentinel* Company.)

IN MEMORIAM
HASSIE K. GRESHAM
1877 – 1970
DEDICATED TO OUR PRINCIPAL
WHO GAVE A LIFETIME OF LOVE
AND SERVICE TO SHAPING THE
MINDS AND CHARACTER OF
YOUNG PEOPLE

ERECTED BY C.H.S. CLASS OF 1945

MEMORIAL PLAQUE. The Central High School Class of 1945 placed a plaque to honor Hassie K. Gresham for her life of service to her students. Miss Gresham is representative of many other dedicated principals and teachers who have served students in our Fountain City schools. These are the carefully chosen words on that plaque:

IN MEMORIAM
HASSIE K. GRESHAM
1877–1970
DEDICATED TO OUR PRINCIPAL
WHO GAVE A LIFETIME OF LOVE
AND SERVICE TO SHAPING THE
MINDS AND CHARACTER OF
YOUNG PEOPLE

ERECTED BY C.H.S. CLASS OF 1945

68

Seven

OUR CHURCHES

The Scotch-Irish pioneers who first settled Knox County brought their religion with them. First the Presbyterians settled along the French Broad River at Lebanon-in-the-Fork in 1791. Not long after that, the Baptists built a log cabin "meeting house" on Beaver Creek in 1800.

Church historians suspect it was even earlier than 1833, but, at least by then, religious meetings were being held in the Fountain Head Park. A congregation that would become the Fountain City Methodist Church South was established near the park in 1825. They built a log cabin church about 1828 and a white frame church in 1845. In 1851, the church purchased the 12-acre wooded grove now known as Fountain City Park and held many campground meetings there, attracting up to 2,000 people to Sunday services.

By the mid-1840s, with the war clouds gathering that would erupt in the Civil War, a group sympathetic to the North split off and, for a time, met in the same building with the southern Methodists. In 1883, they built a small wooden church called Elm Grove on Jacksboro Pike near Smithwood. From 1917 to the late 1950s, the congregation held services at a location in Whittle Springs, moved to their present site off Dutch Valley road in 1961, and is now known as St. Andrews United Methodist Church. Smithwood Baptist Church was established and built in 1845 on land donated by John Smith. Shannondale Presbyterian Church was established in 1886 and built its historic edifice that year. First Baptist Church was organized in 1908, Foster Chapel Baptist Church in 1909, and the other Fountain City churches followed.

Throughout the 20th century, religious observance continued to grow. Fountain City can truly be called, "A City of Churches."

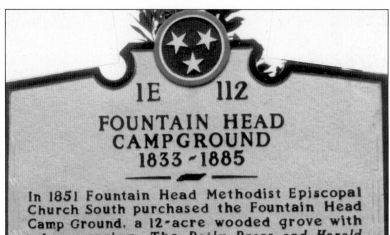

FOUNTAIN HEAD CAMPGROUND. The wooded grove that would eventually become Fountain City Park was a Methodist campground in the 1800s.

IE 112

FOUNTAIN HEAD CAMPGROUND 1833 - 1885

In 1851 Fountain Head Methodist Episcopal Church South purchased the Fountain Head Camp Ground, a 12-acre wooded grove with a large spring. The *Daily Press and Herald* reported this scene in 1869: "All was peaceful since the war with white tents, wagons, and buggies dotting the grove. Early devotions, two daytime services, and the last at 'early candle light' called campers to the white Methodist church. On Sunday 2000 were in attendance." This campground is now the Fountain City Park.

TENNESSEE HISTORICAL COMMISSION

IE 112

FOUNTAIN CITY UNITED METHODIST CHURCH FOUNDED IN 1825

In 1824, E. F. Sevier, grandson of Gov. John Sevier, came to this area as a Methodist circuit rider. By 1825, a plot of ground was secured and Fountain Head became a "preaching place." A log meeting house (c 1828) was built followed by a white frame church (1845). The church, campground, hotel, "the Dummy line" train, and lake nearby all made Fountain Head a popular resort by 1891. A red brick church was built in 1892 with the new name, Fountain City Methodist Episcopal Church, South.

Continued

TENNESSEE HISTORICAL COMMISSION

FOUNTAIN CITY UNITED METHODIST CHURCH. The log meeting house (c. 1828) and the white frame church building (1845) stood near this historic marker.

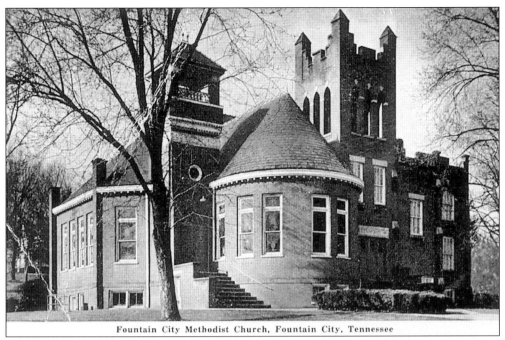

Fountain City Methodist Church, Fountain City, Tennessee

FOUNTAIN CITY UNITED METHODIST CHURCH (1891–1957). The World War II generation that walked up Hotel Avenue to Central High School will remember this unique sanctuary facing Fountain City Park. (Unidentified postcard.)

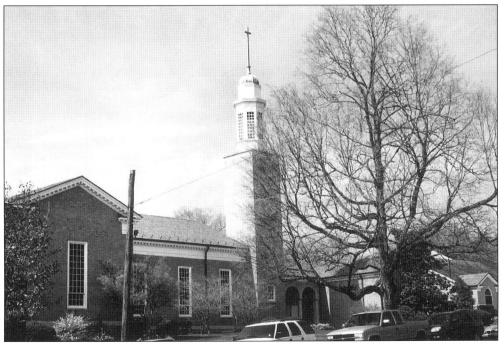

FOUNTAIN CITY UNITED METHODIST CHURCH (1957–PRESENT). The present sanctuary is to the left and the Family Life Center and Sunday school addition to the right.

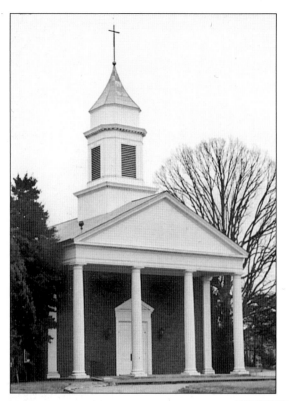

ST. ANDREWS UNITED METHODIST CHURCH. Established in 1825 with roots in the Fountain City Methodist Church and, later, the Elm Grove Methodist Church, the St. Andrews United Methodist Church moved to this sanctuary in 1961.

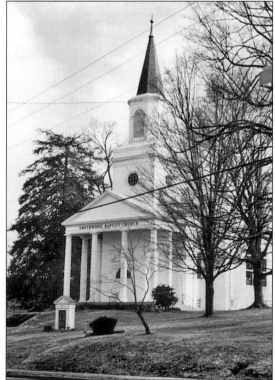

SMITHWOOD BAPTIST CHURCH. Established in 1845 on land donated by John Smith, who is buried in the church cemetery, this Norman Rockwell–like edifice was built in 1916.

SHANNONDALE PRESBYTERIAN CHURCH.
Built soon after the congregation was
established in 1886, this Stephenson and
Getaz–designed church fulfilled the dream
of Mrs. James A. (Anna Morrow)
Anderson, the matriarch of the church.

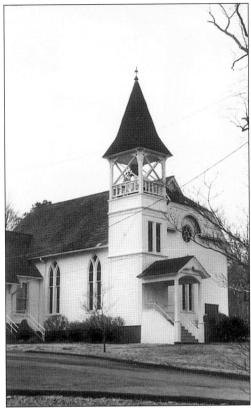

**FIRST BAPTIST CHURCH OF FOUNTAIN
CITY.** The church was established in 1908.
The unique pebble-dash sanctuary stood for
many years until replaced by a stone
building. The minister in the inset is Rev.
M.C. Atchley, the first minister of the
church. Rev. Neill Acuff was the sixth
minister (1920–1924).

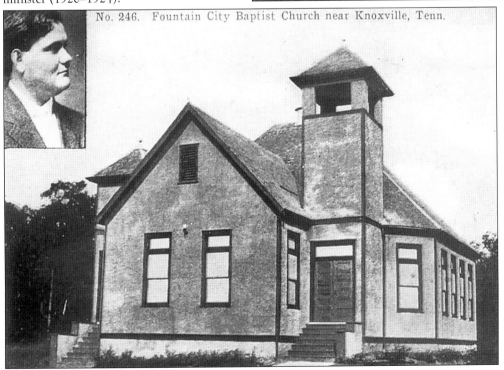

No. 246. Fountain City Baptist Church near Knoxville, Tenn.

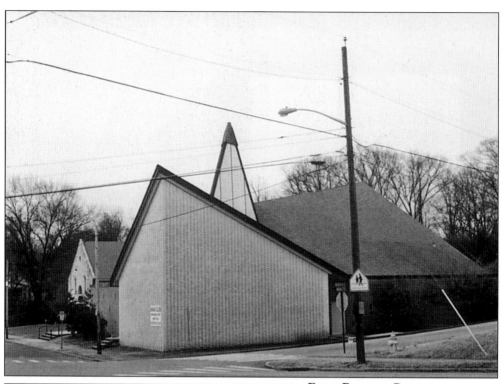

FIRST BAPTIST CHURCH OF FOUNTAIN CITY (1960). With the growth of the congregation, a massive building program in 1960 resulted in this new sanctuary and Sunday school addition.

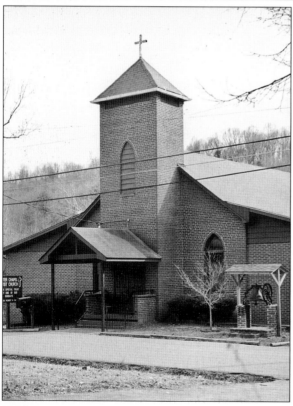

FOSTER CHAPEL BAPTIST CHURCH. Organized in 1909 and occupying this sanctuary built in the 1950s in the heart of the historic Oakland community, this church continues to fulfill its mission. The church bell from an earlier building calls the congregation to worship.

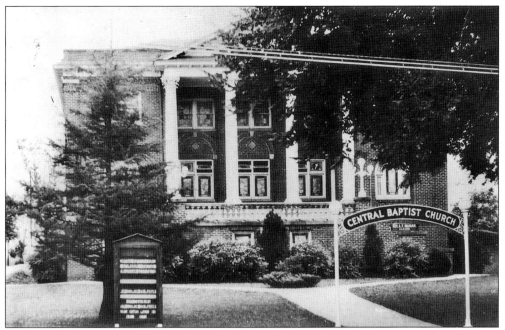

CENTRAL BAPTIST CHURCH OF FOUNTAIN CITY (1924–1950). The congregation was organized in 1914. This represents the second of six building programs since their beginning. (C.M. McClung Historical Collection, 200-152-004.)

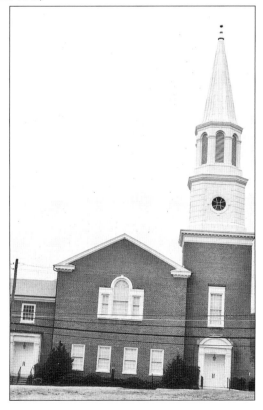

CENTRAL BAPTIST CHURCH OF FOUNTAIN CITY. The current sanctuary was built in their sixth building program in 1997–1998.

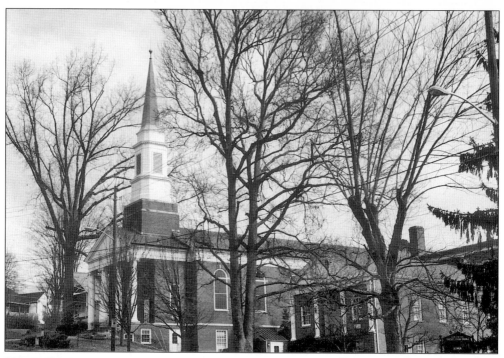

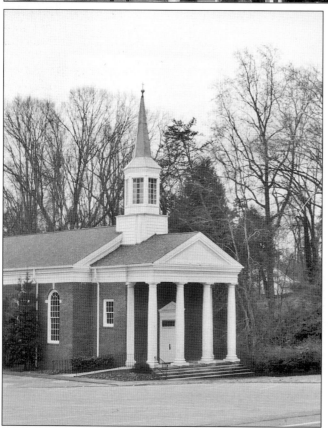

FOUNTAIN CITY PRESBYTERIAN CHURCH. The McCorkle Chapel, founded in 1922 under the leadership of N.D. Barrows of Second Presbyterian Church, Knoxville, was built in 1929. The sanctuary was added in 1951.

ST. PAUL UNITED METHODIST CHURCH. A survey was conducted in the Harrill Hills–Villa Gardens area in 1945 declaring the need for this church. A chapel was built in 1947; the present sanctuary and Sunday school rooms were completed in 1952.

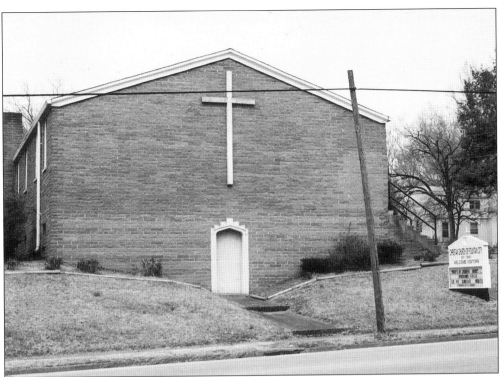

CHRISTIAN CHURCH OF FOUNTAIN CITY. Organized in 1949, the congregation met in a temporary location until the first building program was conducted in 1951. This sanctuary was built in 1957.

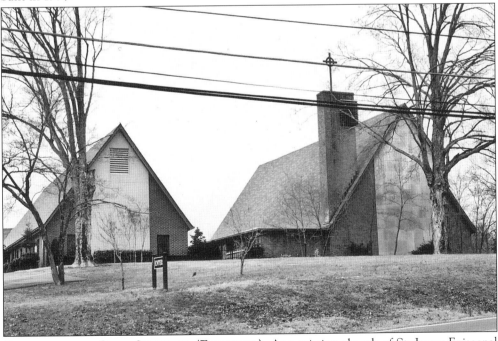

CHURCH OF THE GOOD SHEPHERD (EPISCOPAL). As a mission church of St. James Episcopal Church, this congregation was organized in 1956 and the building was completed in 1958.

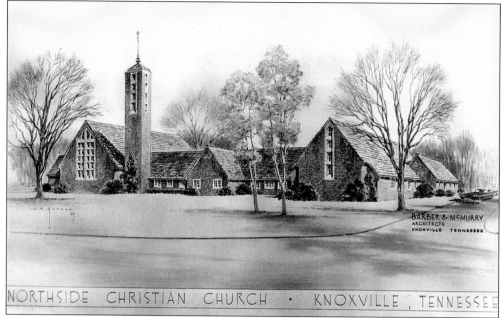

NORTHSIDE CHRISTIAN CHURCH. Following a bequest from John C. Evans, a member of First Christian Church, Knoxville, 77 members were commissioned to organize a new church in Fountain City in 1958. The Barber and McMurry–designed church was dedicated on January 15, 1961.

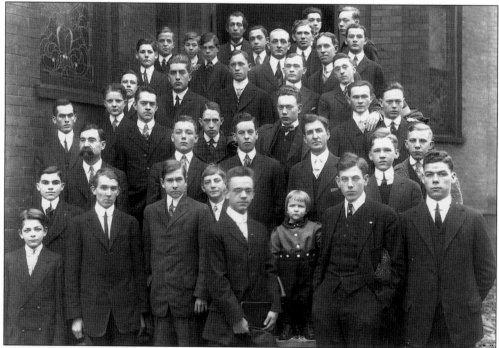

FOUNTAIN CITY CHURCH, YOUNG MEN'S SUNDAY SCHOOL CLASS (MARCH 1915). The stained glass window to the left may indicate that this otherwise unidentified Sunday school group met at Fountain City Methodist Church. (C.M. McClung Historical Collection, GP-312.)

Eight

OUR SPECIAL PLACES AND EVENTS

The biggest event of the year in Fountain City is the annual Memorial Day celebration, "Honor Fountain City Day," sponsored by Fountain City Town Hall. The day's program includes entertainment, games and rides for the children, food booths, presentation of awards, a "Ceremony Honoring Veterans" at the Veteran's Memorial by the lake, and a keynote address by some prominent person. First proposed by Town Hall board member Barbara Ray in 1975, the 2004 event will be the 29th annual "Honor Fountain City Day."

Unfortunately, along the way, some of Fountain City's attractions have been lost. The merry-go-round operated by William E. and Dossie Miller Cooper at the lake was discontinued in the 1930s. Franklin Park, a rugged, child-sized canyon between old Fourth and Fifth Streets, was mostly filled in and grassed over in 1985–1986, when years of accumulation of muck was taken from the lake and hauled there. We no longer have Longmire's Blue Circle Drive-In Restaurant or the Palace Roller Rink and Theatre. However, much that makes Fountain City a desirable place to work and live remains for us to enjoy. We still have many of our historic homes; Littons, the Amber, Louis, and the Creamery please our taste buds. We can still discuss our history while being styled in Wallace's Fountain City Barber and Style Shop.

Thanks to Judge John W. Green, the Park Commission, and the Lions Club, one can still stroll through a well-kept park or take a walk by the lake.

HONOR FOUNTAIN CITY DAY PROGRAMS
Fountain City Park – May 27, 2002

"30 YEARS OF COMMUNITY SERVICE"
Celebrating the 30th Anniversary of Fountain City Town Hall

4:00 p.m. Program at Fountain City Lake
Memorial Day Ceremony Honoring Veterans Congressman John J. Duncan, Jr.

5:00 p.m. Program at Gazebo
Welcome and IntroductionMichael Kane, Chairman Fountain City Town Hall
Invocation ...Rev. Max Reddick, Fountain City Presbyterian Church
Honor Guard ..East Tennessee Veterans Honor Guard
Pledge of Allegiance ...Saint Joseph School Students
Music ...Nancy-Lynne Trentham
Introduction of Honored GuestsMark Williamson, Town Hall Board Member
Introduction of SpeakersMichael Kane, Chairman Fountain City Town Hall
Keynote Address ...Robin Wilhoit, WBIR-TV
Founding of Fountain City Town HallMay Lou Horner, County Commissioner
Introduction of Fountain City Town Hall Board of Directors For 2002-2003
Presentation of Community Awards

Commercial Restoration Award	Soroj Chand and Michael Cohen
	Alternative Counseling Center, 3101 Essary Drive
Residential Restoration Award	Libby Mills and Joe Whaley
	2805 Gibbs Road (Dempster-Francis House)
Residential Beautification Award	Irene McCrarey
	4514 Villa Road
Friend of Fountain City	Sam Parnell, Jr., Director of Engineering and the
	City of Knoxville Engineering Department
Chairman's Award	Ed Pasley, Staff and Volunteers
	of the Dogwood Arts Festival
2002 Fountain City Woman of the Year	To be announced
2002 Fountain City Man of the Year	To be announced

Presentation of Door Prizes

2002 HONOR FOUNTAIN CITY DAY PROGRAM. In 2002, Fountain City Town Hall observed its 30th anniversary and that was the theme for the program. Congressman John J. Duncan Jr. conducted the Ceremony Honoring Veterans. The program is always printed on a fan to make it both functional and informative.

WOMAN AND MAN OF THE YEAR. Mary Lou Horner, Knox County commissioner, and Thomas Schumpert, Knox County executive, both Fountain City natives, were awarded the first of these annual awards in 1975. (*Halls Shopper News* File Photos, used with permission.)

PUBLIC SERVANTS PRESENT, PATRIOTISM EMPHASIZED. County Commissioner Horner, Chief of Police Phil Keith, and Vice Mayor Jack Sharp are always in attendance. (*Halls Shopper News* File Photos, used with permission.)

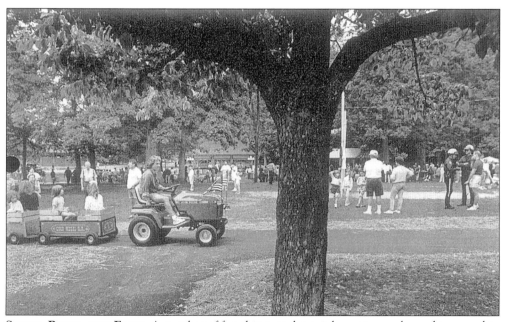

SLIDES, RIDES, AND FOOD. A number of fun things and special events are planned to appeal to the large number of children who attend every year. (Reprinted by permission of *The Knoxville News-Sentinel* Company.)

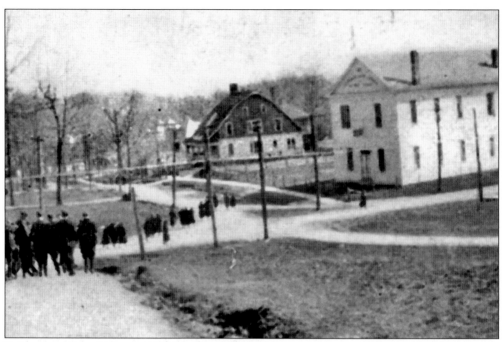

FOUNTAIN CITY LIBRARY (1929–1936.) With a County Court appropriation of $2,500, the first Fountain City library opened in rented space in the Odd Fellows Hall on January 22, 1929.

FOUNTAIN CITY LIBRARY (1936–1964). Judge John Green spearheaded a fund for a new freestanding library. In 1936, under his chairmanship, a committee raised $3,000 to build this building. (Ella Mae Worman Collection.)

ELLA MAE THOMPSON WORMAN,
BRANCH LIBRARIAN FROM 1953 TO
1956. This is a 1987 portrait of the
branch librarian who managed the library
during a period of rapid growth
influenced by a larger building and better
location. (Ella Mae Worman Collection.)

GLADYS CARPENTER BARKLEY, BRANCH
LIBRARIAN FROM 1956 TO 1966. During
the last full year in the old library (1962),
circulation grew to 70,000 books and
there was no more shelf space.

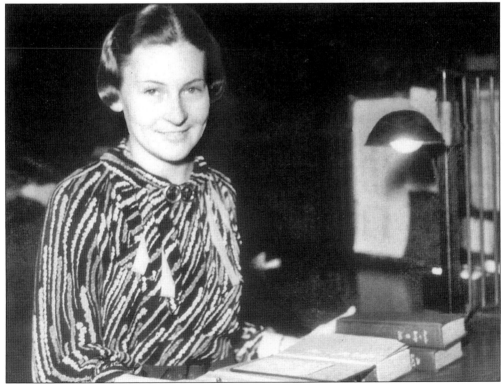

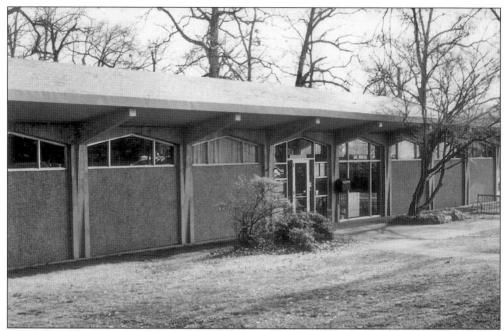

NEW LIBRARY FUNDED. After Fountain City was annexed into the City of Knoxville on January 1, 1963, the Knoxville Public Library system funded a new 4,000-square-foot building. (Barber and McMurry, Architects.)

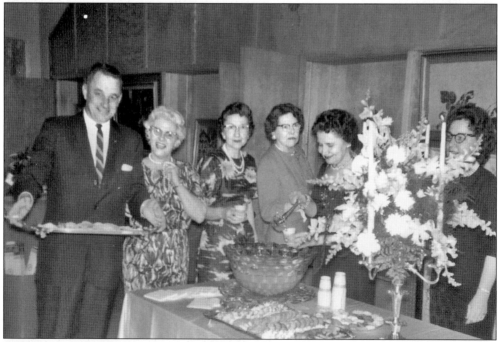

DEDICATION OF THE NEW BUILDING IN JUNE 1964. Fountain City Library Board chairman Frank Ogden served those attending the ceremony. The following are pictured from left to right: Mr. and Mrs. Frank Ogden, Gladys Warren, and three unidentified persons. (Ella Mae Worman Collection.)

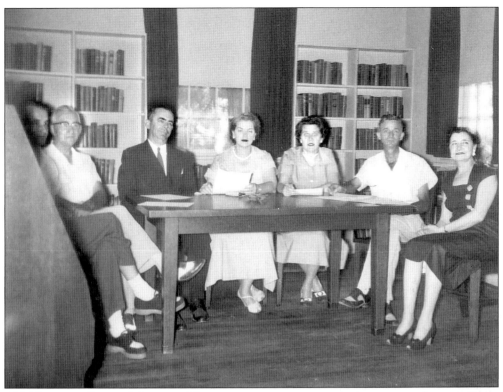

1964 LIBRARY BOARD MEMBERS. The following board members are pictured from left to right: Frank Ogden, R. Cliff White, Rev. Charles Bond, ? Hodge, ? Hawes, "Jut" Harris, and Delila Angus. (Ella Mae Worman Collection.)

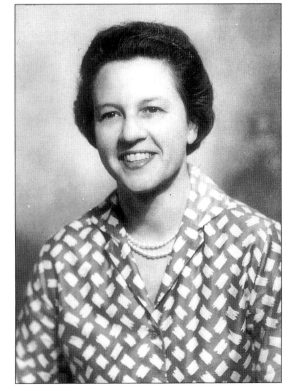

WILLIA S. "BILLIE" MCKINNEY, BRANCH LIBRARIAN FROM 1967 TO 1975. General usage and circulation figures increased again with the move into a new, well-lighted building. The design provided extraordinarily pleasant lighting under the canopy of large trees in the park that surrounded the library.

85

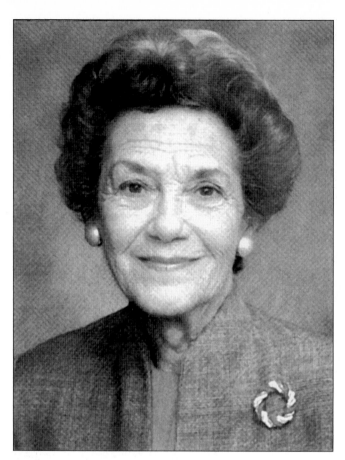

MARY ORR LONGFELLOW, LIBRARY STAFF FROM 1969 TO 1985. Many children were introduced to books during Mrs. Longfellow's favorite library time, the weekly children's story hour. Elizabeth "Libby" Nelson became branch librarian in 1986 and continues to serve in that capacity.

NEW LIBRARY CAMPAIGN. In 2000, the Knox County Commission acquired a 2.2-acre parcel on Essary Road at Stanton Drive. The $2.25 million, 12,000-square-foot building is scheduled for occupancy in June 2004.

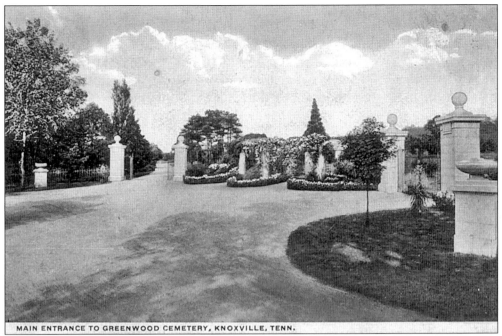

MAIN ENTRANCE TO GREENWOOD CEMETERY, KNOXVILLE, TENN.

MAIN ENTRANCE, HISTORIC GREENWOOD CEMETERY. The cemetery was founded in 1900 by Dr. R.N. Kesterson (1858–1931). Dr. and Mrs. Kesterson traveled widely to find a model for the "Place of Beauty Forever" they established on Tazewell Pike. They found their "model" cemetery in New York State. (Published by Curt Teich & Co.)

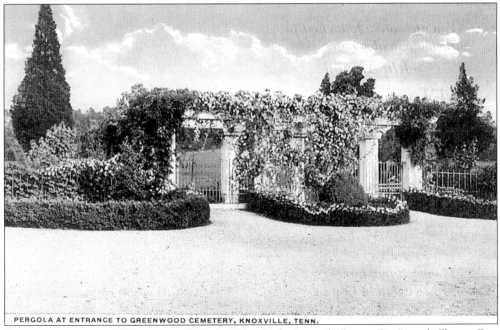

PERGOLA AT ENTRANCE TO GREENWOOD CEMETERY, KNOXVILLE, TENN.

PERGOLA NEAR THE ENTRANCE. This is "The 34th Annual Flower Day" card. Flower Day featured a memorial address by Rev. R.C. Wyatt, pastor of McCalla Avenue Baptist Church. (Published by Curt Teich & Co.)

87

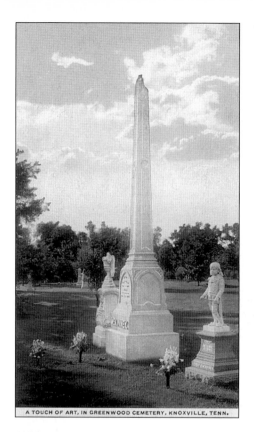

A TOUCH OF ART, IN GREENWOOD CEMETERY, KNOXVILLE, TENN.

ARTISTIC MONUMENT SIMILAR TO MANY IN THE CEMETERY. This is another of a series of postcards issued for the 27th Flower Day. (Published by Curt Teich & Co.)

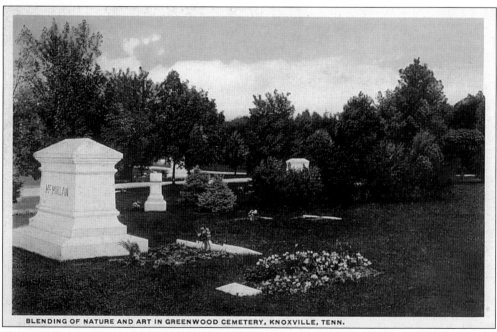

BLENDING OF NATURE AND ART IN GREENWOOD CEMETERY, KNOXVILLE, TENN.

NATURE BLENDS WITH ART. The landscaping and specimen trees, shrubs, and flowers made this a nationally-recognized, prize-winning cemetery. (Published by Curt Teich & Co.)

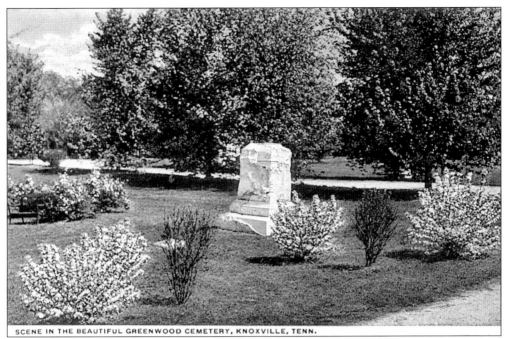

SCENE IN THE BEAUTIFUL GREENWOOD CEMETERY, KNOXVILLE, TENN.

SCENE IN THE BEAUTIFUL CEMETERY. A riot of color still greets visitors each spring as flowers and shrubs bloom in profusion. (Published by Curt Teich & Co.)

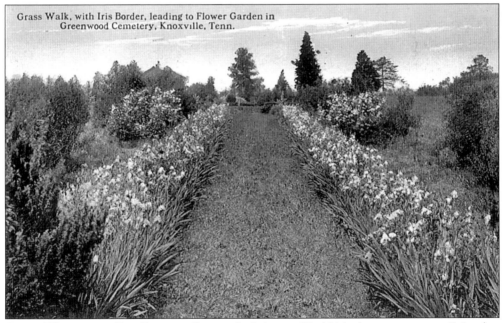

Grass Walk, with Iris Border, leading to Flower Garden in Greenwood Cemetery, Knoxville, Tenn.

GRASS WALK WITH IRIS BORDER. Postmarked August 20, 1914, the message says, "My what hot weather we are having, almost smother." Evidently, the August weather at that time was as hot and humid as today. (Published by Curt Teich & Co.)

REUBEN N. KESTERSON, D.D.S. (1858–1931). Dr. Kesterson's first son, Robert Neil (1887–1890), was lost to a childhood illness at three years of age. Dr. Kesterson was so aggrieved that he took a year to travel nationwide seeking a model for the cemetery that would be his son's final resting place. (Thomas H.D. Kesterson, used with permission.)

KESTERWOOD (1928). Dr. Kesterson's home, Kesterwood, was built in 1928 in Smithwood near the second Tazewell Pike entrance to Greenwood Cemetery. It is said that the dormer windows on the home were built to permit a view of his son's monument, a tall obelisk about 1,000 yards distant.

ARTHUR SAVAGE (1872–1946).
Mr. Savage, a native of Leamington, England, came to Fountain City in 1914. A partner in Ty-Sa-Man Machine Company, manufacturer of flour mill and marble mill machinery, his love of English gardens led him to establish this one in Fountain City on Garden Drive. (Bill Dohm Collection, used with permission.)

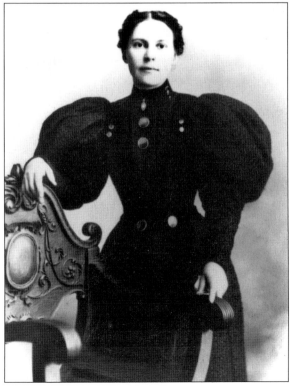

HORTENSE GARRETT SAVAGE (1871–1953). A native of Jefferson County, Tennessee, Hortense married Arthur Savage in 1895. Like her husband, she was an avid flower hobbyist. (Bill Dohm Collection, used with permission.)

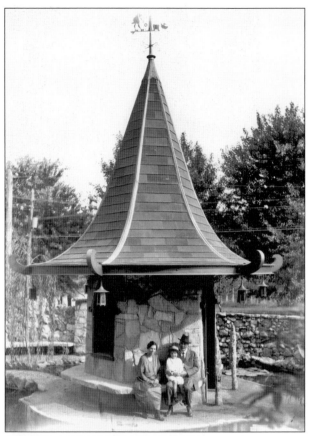

STONE PAGODA. By 1926 various stone works, including this pagoda, had taken shape. Arthur Savage with wife, Hortense, and son Robert are seen in this photo. (Bill Dohm Collection, used with permission.)

PRESENT OWNERS, BILL DOHM AND HIS WIFE, PATTY COOPER. Shown with their son Caleb in 1990, the Dohms bought the property in 1986. They continue to cultivate the rare and beautiful shrubbery and maintain the structures. (Reprinted by permission of *The Knoxville News-Sentinel* Company.)

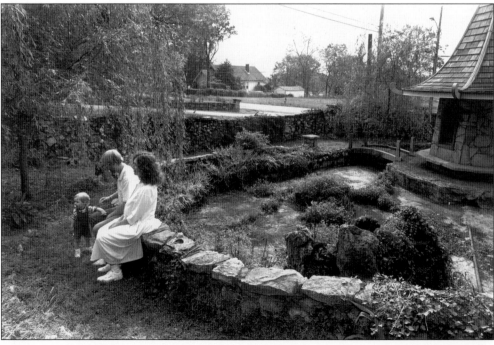

IRISH TOWER. One the first structures built (*c.* 1920) by the Savages' master stonemason, Charlie Davis, was this Irish Tower. (Reprinted by permission of *The Knoxville News-Sentinel* Company.)

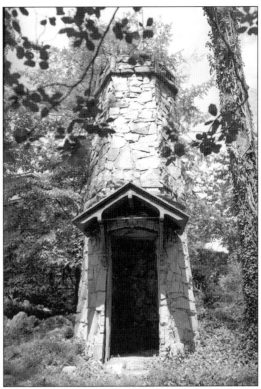

CHARLIE DAVIS AND HIS DAUGHTER IVA. Charlie Davis worked in the Savage Gardens five days each week for 17 years. In 1937, he departed to accept a similar challenge at Weston Fulton's estate grounds on Lyons View Pike. (Bill Dohm Collection, used with permission.)

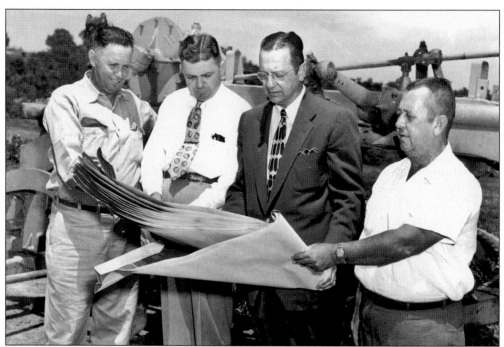

FIRST PRESIDENT OF THE FOUNTAIN CITY RECREATION COMMISSION, 1953. President A.L. Jenkins, M.D., Fountain City pediatrician, and his team prepare for opening day of the playing fields. The following are pictured from left to right: unidentified, Jerry Meadows, Dr. A.L. Jenkins, and Joe Cox. (Dr. A.L. Jenkins Collection.)

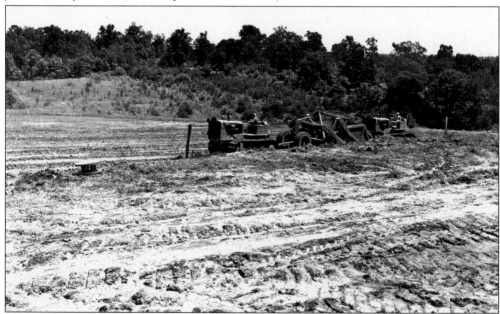

SCENE TWO WEEKS FROM OPENING DAY. Just two weeks after this photograph was taken several of the leagues "played ball." Thousands of children and youth have been entertained by the recreation programs and, more than 50 years later, the park still serves the community. (Dr. A.L. Jenkins Collection.)

FRANKLIN PARK. The park was across from the Perry B. Conner House on Fourth and C Streets. In the 1930s and 1940s, Franklin Park had lots of tall trees, big boulders, and grape vine swings and formed a perfect "set" for a western movie or a place to play *Tarzan*.

THE FRANKLIN PARK "CANYON." The ravine was much deeper prior to 1985 and many school children in the western end of Old Fountain City used it as a short-cut to Fountain City Grammar School. In 1985, the muck removed from Fountain City Lake during refurbishment was used to bury the giant boulders.

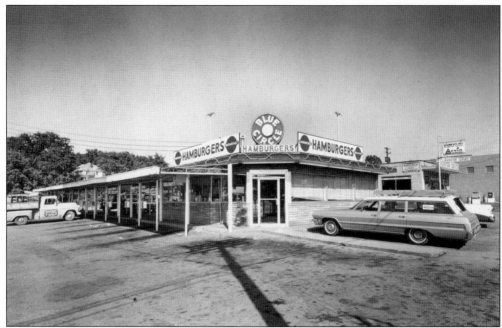

THE BLUE CIRCLE DRIVE-IN RESTAURANT (1964). C. Homer Longmire (1892–1966) founded the Blue Circle Restaurants in 1931 and, by 1948, had seven locations in East Tennessee with more to come. The Fountain City drive-in was a favorite after-school and evening hangout for teenagers. (Bill Tracy Photography.)

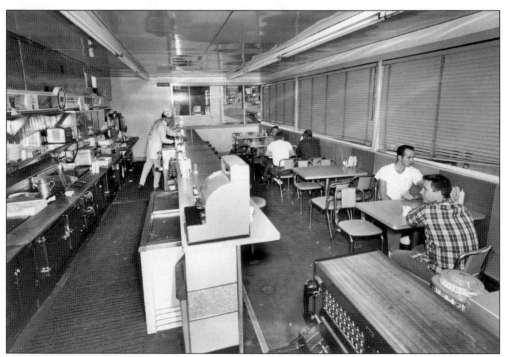

INTERIOR OF THE BLUE CIRCLE. Many will remember the hamburgers with diced onions and the pork barbecue with slaw. (Bill Tracy Photography.)

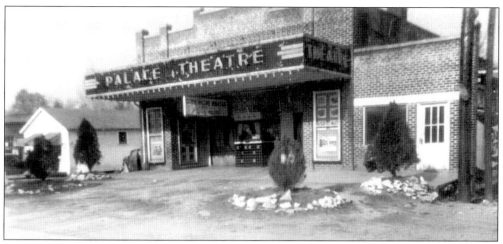

THE PALACE THEATRE (C. 1945). Located on Broadway near the present location of Food City, the theatre was a popular first-run theatre from its opening in 1936 until its closing in 1948. The manager was T.W. Smith. (Flora B. Poore Collection.)

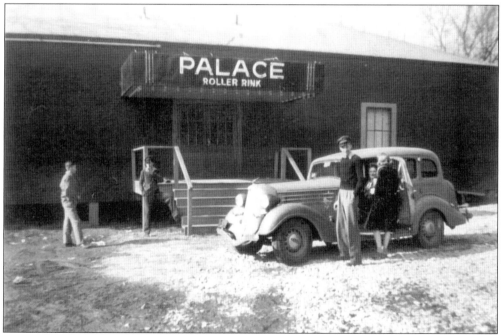

THE PALACE ROLLER RINK. A popular place for teenagers to gather, the roller rink faced Essary Road back to back with the theatre. Zella Dyer managed it. The young man standing by the car is Paul T. Stamps and the driver is Frances Brakebill Gladden. The others are unidentified. (Flora B. Poore Collection.)

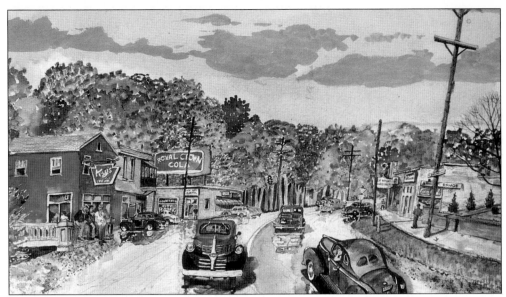

THE STATION. The central business area of Fountain City is called "The Station," since that is where the Dummy Line train had its terminus. Artist Bill Kidwell (Central High School, 1954) painted the 1950s intersection of Hotel Avenue and Broadway (looking north) as he remembered it with Kay's Ice Cream anchoring the corner. (Bill Kidwell, used with permission.)

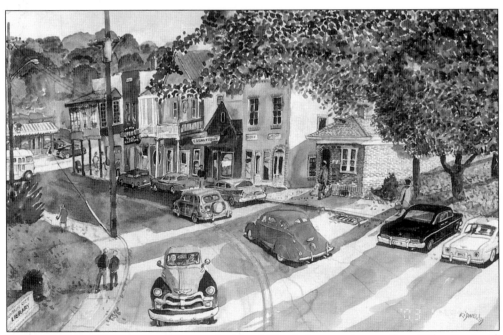

HOTEL AVENUE BUSINESSES. The south side of Hotel Avenue (across from "The Station") looked like this in the 1950s. Kidwell is painting a series of 12 Fountain City scenes, including one many remember well—Tallent's oval-glassed front door seen here midway in the row of buildings. (Bill Kidwell, used with permission.)

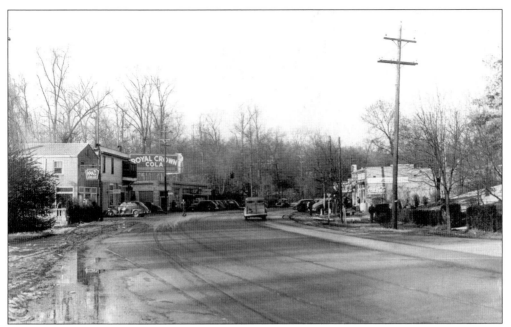

BROADWAY AT HOTEL AVENUE (1962). Ten years after the previous photograph things have changed very little. The heavily wooded Fountain City Park (beyond the Royal Crown Cola sign) is less so now, following a dramatic drop in the water table one summer in the 1970s. (Reprinted by permission of *The Knoxville News-Sentinel* Company.)

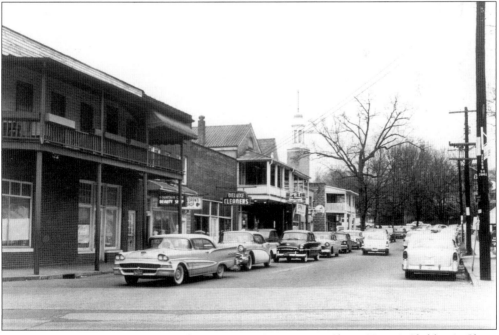

LOOKING UP HOTEL AVENUE. The Fountain City Beauty Shop, Harris' Children's Shop, Clark's Deluxe Cleaners, and Tallent's Drug Store can be seen on the left. That is "Mayor" Dossie Cooper's balcony on the first building on the left from which she supervised the area. (Reprinted by permission of *The Knoxville News-Sentinel* Company.)

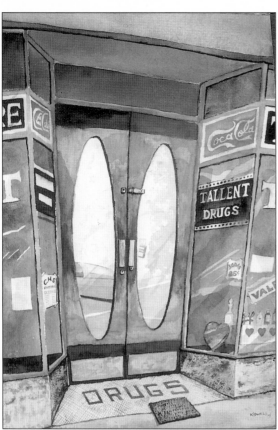

DOC TALLENT'S DOOR BY BILL KIDWELL. Thousands of students passed through this door on the way home from Central High School in need of a Coke or a milk shake. (Bill Kidwell, used with permission.)

JOSEPH FRED TALLENT'S DRUG STORE. In this location on historic Hotel Avenue, J. Fred Tallent (1902–1987) ran his pharmacy the old fashioned way. Whether you had a prescription filled or bought a cold remedy, you received a package of gum or peanuts as a bonus. (Ruth Ford Wallace Collection.)

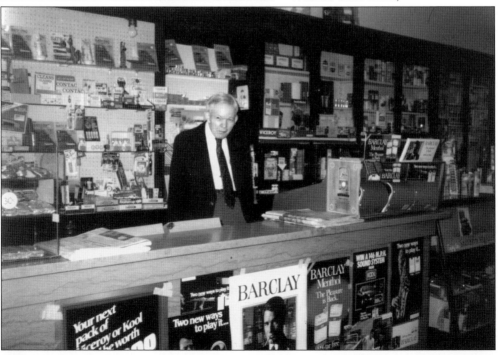

Nine

OUR SPECIAL PEOPLE

If the history of a community is written in the lives of its populace—and it is—then Fountain City has a very rich history. The contributions many have made, not only while they lived here, but also after they moved elsewhere, have benefited us all.

Roy Acuff is an example. He was 16 when his family moved from Maynardville to Fountain City and his father became minister of the First Baptist Church of Fountain City. Roy attended Central High School for four years, graduating in the Class of 1924. In 1937, his star began to rise in Nashville; many years later he formed the Acuff-Rose Music Publishing Company and was declared "King of Country Music." When his alma mater staged a fund-raiser in 1988 to replace a small, aging athletic field house, it was Roy Acuff who gave a check for $25,000 toward the fund. Roy remembered his formative years in Fountain City and in Central High School.

Ellen McClung Berry played a pivotal role in saving Ramsey House and Glenmore Mansion for future generations. She also helped to establish the Association for the Preservation of Tennessee Antiquities and served as its president in 1955–1956.

Harvey B. Broome and Carlos C. Campbell played major roles in the nation's conservation efforts by popularizing the Great Smoky Mountains and gaining its national park status. Broome's Out Under the Sky of the Great Smokies (1975), published posthumously by his wife, has influenced many in their quest for the great outdoors through its Thoreau-like passages. He and eight others founded the Wilderness Society in 1935. Broome served on the original governing council, assumed the office of president of the group in 1957, and continued in that capacity until his death in 1968. Campbell's book Birth of a National Park in the Great Smoky Mountains, written in 1960 and reprinted three times, describes the prolonged, but successful, effort he and a small committee made to achieve the goal of a national park for East Tennessee.

Dr. Bruce R. McCampbell, general surgeon, was a member of the two-surgeon team that performed the first homograft for a ruptured abdominal aortic aneurysm in the United States. His book, Tell Me 'Bout the Good 'Ole Days, Papa Bruce (1993) contains one of the few published accounts of growing up in Fountain City.

These and many others contributed to our admirable heritage. Fountain City has been home to many special people.

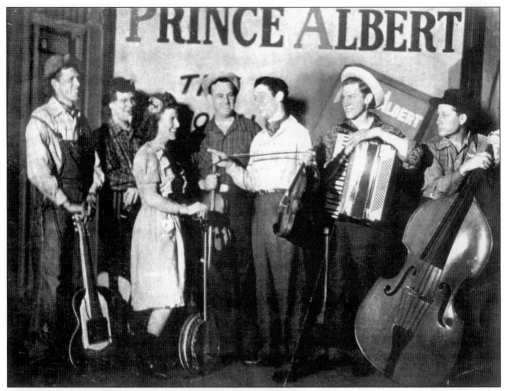

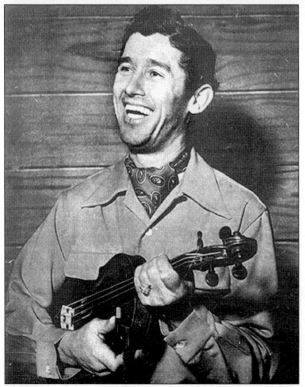

Roy Acuff and The Smoky Mountain Boys. The dobro player on the left is Pete Kirby, better known as Bashful Brother Oswald, a brother-in-law to Fountain City historian, Evelyn Goddard Kirby. (Evelyn Goddard Kirby Collection.)

Roy Claxton Acuff (1903–1992). In 1938, Acuff was invited to sing at the Grand Ole Opry in Nashville and soon became a hit performer. Through his stage appearances and his partnership in Acuff-Rose Publishing Company, he made a lasting impact on the music world. (Evelyn Goddard Kirby Collection.)

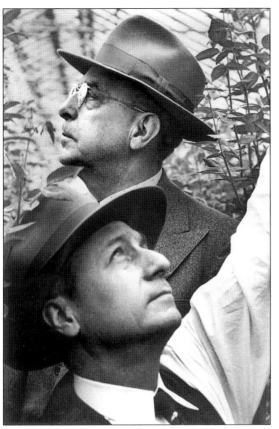

KARL AND FLOYD BAUM OF BAUM'S HOME OF FLOWERS. Karl P. Baum (1885–1977) became president of the firm in 1944 upon the death of his father, Charles L. Baum (1863–1944); Floyd F. Baum (1898–1985) was vice president. They employed more than 20 workers in Fountain City. (C.M. McClung Historical Collection, 200-214-105, Charles Baum.)

BAUM'S GREENHOUSES, FOUNTAIN CITY. Founded by Charles L. Baum in 1889, Baum's Greenhouses grew to become one of the largest in the Southeast with 340,000 square feet of glass in their Smithwood and Bearden locations. (C.M. McClung Historical Collection, 200-214-021, Charles Baum.)

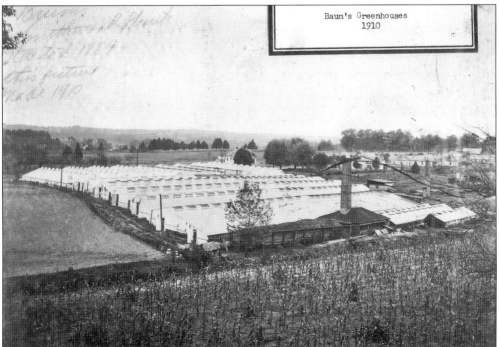

Baum's Greenhouses
1910

ELLEN MCCLUNG BERRY (1893–1992). Highly cultured and widely traveled, Ellen M. Berry was the wife of coal magnate Thomas Berry, a scion of the Berry family of Georgia. She was interested in and knowledgeable about history, art, and architecture. (C.M. McClung Historical Collection, Belcaro Album.)

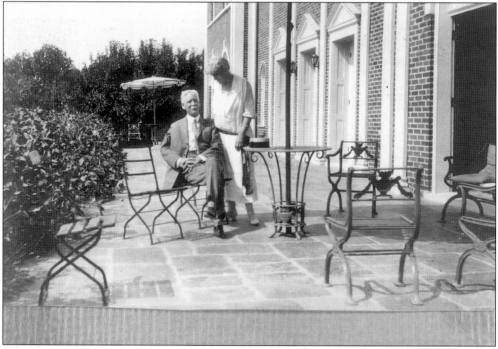

JUDGE HUGH LAWSON MCCLUNG (1858–1936) AND ELLA GIBBINS MCCLUNG. A great-grandson of James White, founder of Knoxville, Hugh McClung graduated from the University of Tennessee, then "read" law under his brother-in-law, Maj. Thomas S. Webb. He was the president of the Holston Bank for five years and a trustee of the University of Tennessee. (C.M. McClung Historical Collection, Belcaro Album.)

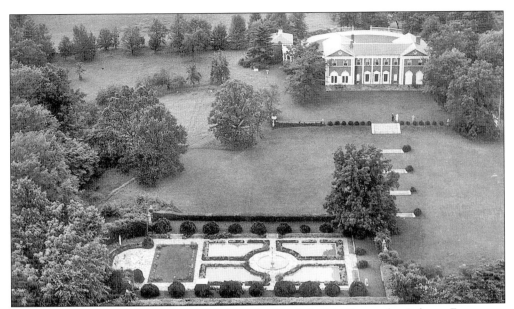

THE BELCARO ESTATE. Built in 1922–1923 by Hugh L. McClung, the Belcaro Estate was designed by his daughter, Ellen, who admired the Corinthian capitals and Palladian windows she had seen in Italy. In planning the colonnades on the north side of the mansion, she visited George Washington's Mount Vernon for the perspective and the measurements. (University of Tennessee Special Collections.)

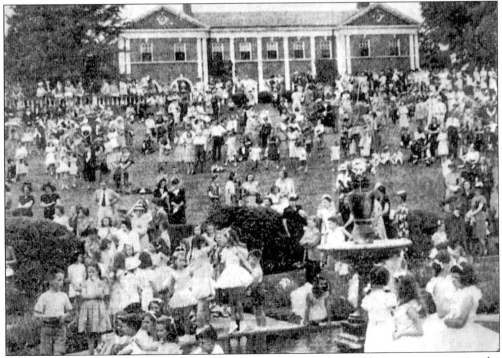

BALLET BENEFIT FOR FOUNTAIN CITY LIBRARY FUND. The children participating in the benefit are pictured in the garden and around the elegant fountain of the estate. (University of Tennessee Special Collections.)

HARVEY BENJAMIN BROOME (1902–1968). A graduate of University of Tennessee and Harvard Law School, Harvey Broome was a law clerk to Federal Judge Robert L. Taylor and an avid hiker for many years. His wife Anna edited his journals and published them in three books posthumously: *Harvey Broome: Earth Man* (1969), *Faces of the Wilderness* (1972), and *Out Under the Sky in the Great Smokies* (1975). (C.M. McClung Historical Collection.)

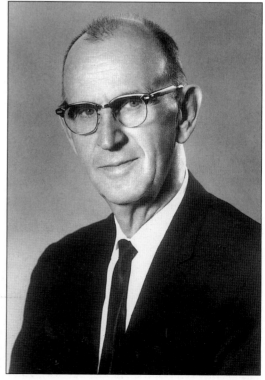

CARLOS CLINTON CAMPBELL SR. (1892–1978). A 1912 graduate of Central High School, Carlos Campbell was manager of the Knoxville Chamber of Commerce. He was an influential member of a small group that obtained national park status for the Great Smoky Mountain National Park. He co-authored *Great Smoky Mountains Wildflowers*, now in its fifth edition. (Reprinted by permission of *The Knoxville News-Sentinel* Company.)

106

FOUR GENERATIONS OF CONNERS
(1932). Descended from William B.
Conner Sr. (1760–1836) of
Menefee's Station in Powell, four
generations of Conners are pictured
from left to right: George Washington
Conner (1849–1934), Perry B.
Conner (1875–1951), Ulysses W.
Conner (1898–1960), and Edward P.
Conner (1930–). (Edward P.
Conner Collection.)

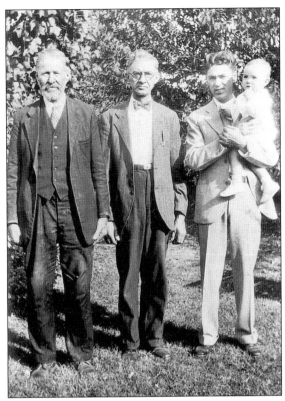

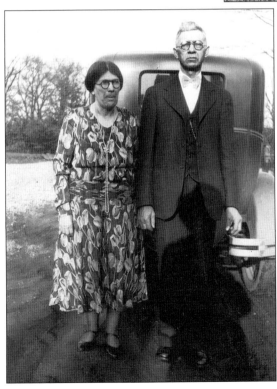

OLLIE CARNEY CONNER (1874–1940)
AND PERRY B. CONNER
(1875–1951). Perry B. Conner was
the chief chemist at Knox Knit
Manufacturing Company. The family
home was at old Fourth and C Streets
across from Franklin Park ("The
Holler"). (Patricia C. Hill Collection.)

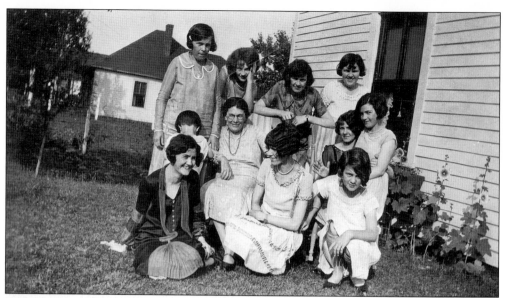

THE CONNER GIRLS AND THEIR MOTHER. The following are pictured from left to right: (seated) Ollie (the girls' mother), Jessie, Beryl; (kneeling) Edna Pearce Conner (the girls' sister-in-law), Edith O'Brien (a friend), and Mildred; (standing) Iola, Kathleen, Gladys, and Wilma. The little girl with her back to the camera is Janie, a granddaughter. (Rose M. Cox Collection.)

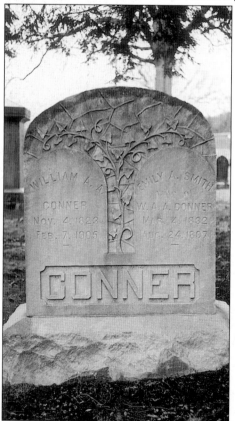

WILLIAM A.A. CONNER (1823–1905) AND EMILY SMITH CONNER (1832–1897) MONUMENT. Also a descendant of William B. Conner Sr. (1760–1836), William A.A. Conner owned the land from Smithwood to present-day Broadway at Hillcrest and was a principal in the Tazewell Turnpike Commission. Conner Station, Conner Avenue, and Rennoc Road are all named for him. Emily Conner was a granddaughter of John Smith. This monument stands in Smithwood Baptist Church Cemetery.

L. Glenard Gentry (1904–1971).
A member of the Central High
School graduating class of 1923,
Glenard Gentry founded Gentry
Mortuary in 1948. He was active in
the Lions Club and a member of the
Fountain City Park Commission.
(Edgar Gentry Jr. Collection.)

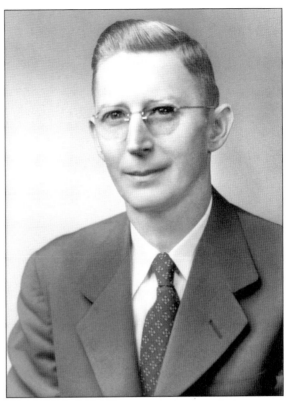

**Lakeview (The Woodward-
Morgan-Gentry House).**
Originally, the main façade was on
the Cedar Lane or the south side of
the mansion as shown here. Col. J.C.
Woodward built it for his son about
1890. It was owned by Dr. Gideon H.
Morgan at the time that he wrote his
autobiography in 1913 and is pictured
in his book. (Gentry-Griffey Funeral
Chapel Collection.)

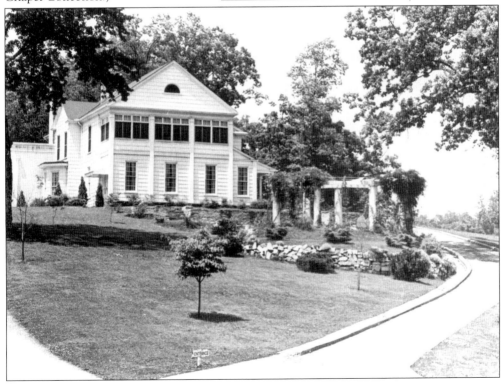

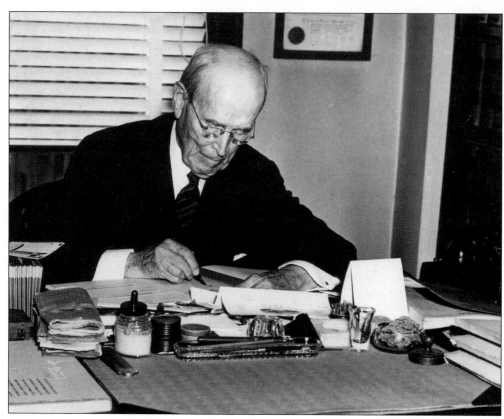

JUDGE JOHN WEBB GREEN (1859–1957). Admitted to the bar in 1880, Judge Green's legal expertise and counsel was essential to preserving Fountain City Lake and Park for future generations. He was chairman of the Knox County Board of Education for 14 years and the Lawson McGhee Library Board for 70 years, and he was the founding president of the Fountain City Park Commission. (Frank H. McClung Collection, University of Tennessee.)

FRANCIS MARION GREEN (1823–1864) AND SUSAN WEBB GREEN (1833–1913). John W. Green was only five years old when his father, the colonel of the 11th Mississippi Infantry Regiment, was mortally wounded at the Battle of Spotsylvania Court House, Virginia (May 12, 1864). John's widowed mother encouraged her two boys to be readers and saw that they received the best possible education. (Frank H. McClung Collection, University of Tennessee.)

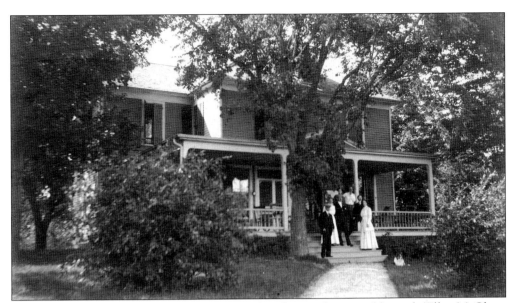

RIDGEVIEW I ON BLACK OAK RIDGE (C. 1902). John W. Green and his wife, Ellen McClung Green (1872–1956), made their home on Laurel Avenue at Eighth Street but built this summer home on Black Oak Ridge about 1902. The couple both loved their flower and vegetable gardens and John Green kept saddle and carriage horses. (Frank H. McClung Collection, University of Tennessee.)

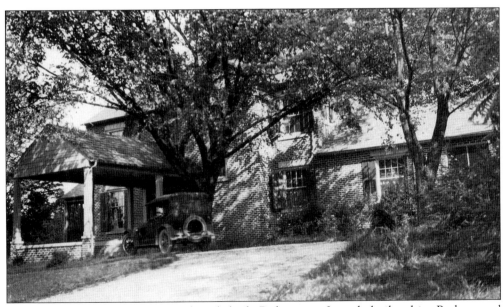

RIDGEVIEW II. The Greens demolished Ridgeview I and built this Barber and McMurry–designed home on the site in 1922. In 1927, the judge published the first of his five books, *Travels of a Lawyer*, an account of their extensive Cunard Lines Mediterranean Cruise, while living here. (Frank H. McClung Collection, University of Tennessee.)

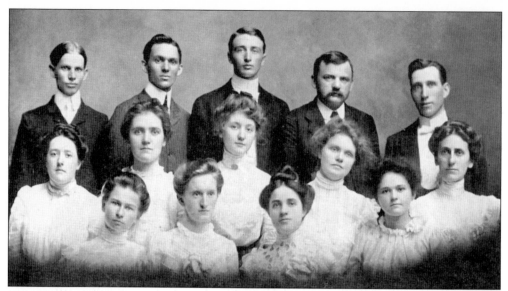

Holbrook Normal College Class of 1902. The distinguished young graduate on the far right in the second row is Miss Hassie Kate Gresham of Jonesborough, Tennessee. Miss Gresham, principal of Central High School from 1919 to 1947, spent many years of her life on "The Hill," since Central High School eventually occupied the Holbrook College Main Building. (Lucile Jones Collection.)

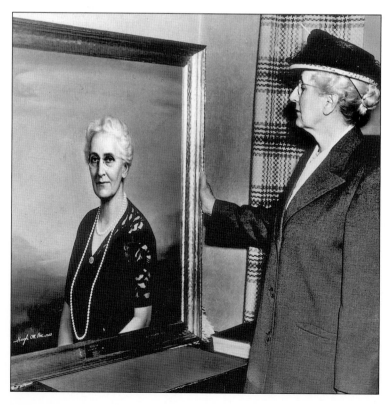

Gresham Oil Painting Unveiled. Through a subscription fund, a Pittsburgh artist, Hugh Poe, a former Knoxvillian, was commissioned to paint this portrait of Miss Gresham. She was present for the unveiling on March 25, 1948. The painting was placed in the main corridor of Central High School with an inscription that reads, "A great teacher; a great builder of character." (Reprinted by permission of *The Knoxville News-Sentinel* Company.)

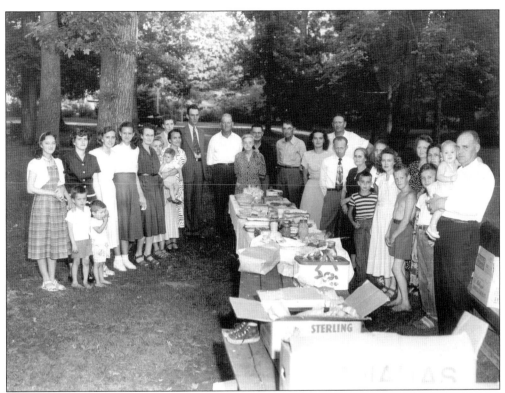

PATRICK IRELAND HANSARD (1889–1972) AND FAMILY. The Hansard family, like many other Fountain City families, used Fountain City Park for family picnics. P.I. Hansard (on the far right), father of Mack and Jay Hansard, Central High School football stars in the 1940s, holds his granddaughter, Brenda Law. (Vivian L. England Collection.)

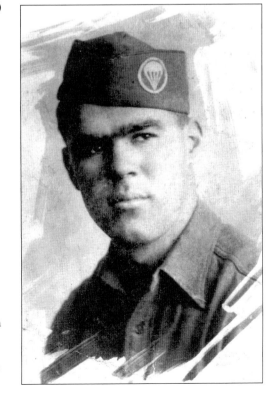

PFC. LEROY JAY HANSARD (1924–1944). Jay, a member of the 82nd Airborne Division, was killed in action in Belgium on October 1, 1944. The family requested that this hero of World War II be brought home in 1949 to rest in the National Cemetery in Knoxville. (Vivian L. England Collection.)

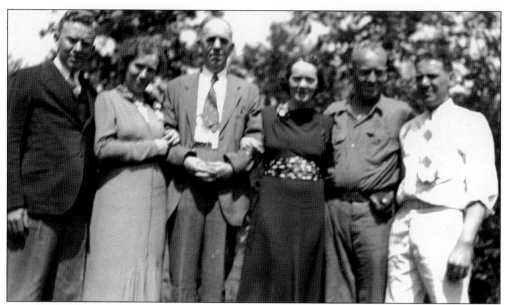

THE HARRINGTON FAMILY. T.R. Harrington Sr. owned a grocery store across from the park next to Copeland's Garage. The family included Central High School athletes and Lions Club members, and Joe was a member of the Fountain City Park Commission. They are pictured from left to right above: T.R. Harrington Jr., Minnie Harrington Johnson, T.R. Harrington Sr., Grace Harrington Able, Joseph J. (Joe) Harrington, and John H. Harrington. (Chloe Harrington Collection.)

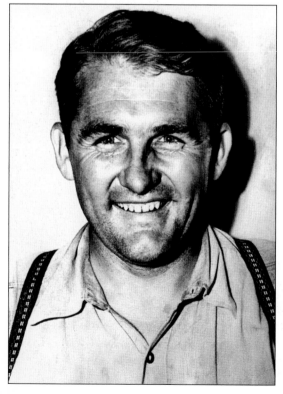

STALEY HENSLEY (1905–1950). Staley Hensley was a pillar of the community and supporter of the Fountain City Recreation Center and Lions Club activities. (Johnnie C. Hensley Collection.)

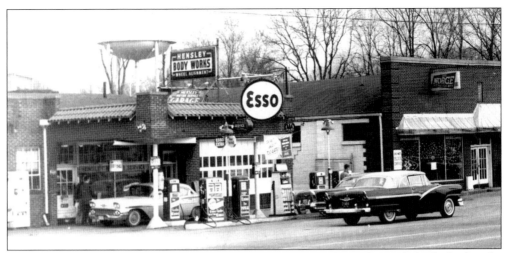

HENSLEY MOTOR SERVICE. The motor service was managed by Staley and the body shop by Bearl Hensley. It was located on Broadway across from the Fountain City Bank and was a place for good conversation as well as good automotive service. (Johnnie C. Hensley Collection.)

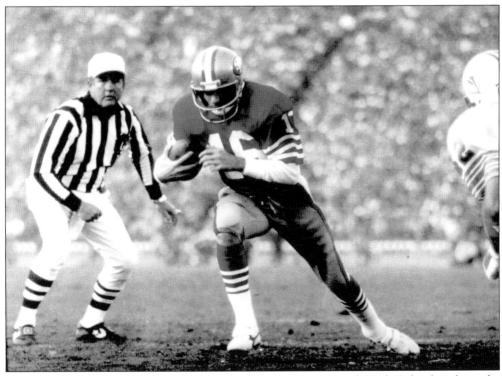

THOMAS B. HENSLEY (1932–1994). After excelling at Central High School and on the University of Tennessee football team, Staley's son, Tom Hensley, became an NFL referee. This image shows him as he referees Super Bowl XIX. Quarterback Joe Montana is scoring a touchdown as the San Francisco 49ers beat the Miami Dolphins by a score of 38–16. (Johnnie C. Hensley Collection.)

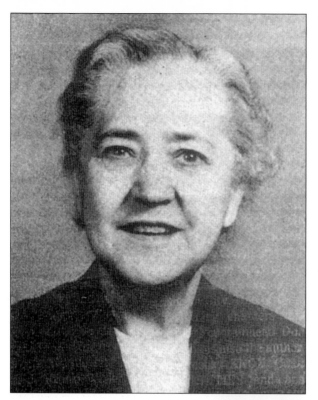

NANNIE LEE HICKS (1889–1979). Miss Hicks taught American history at Central High School for 41 years. Her book, originally titled *The John Adair Section of Knox County, Tennessee* (1968), has been re-titled *A History of Fountain City*, and is now in its fourth edition (2000). Her pioneering teaching method encouraged many of her students to have a lifetime interest in our local, state, and national history.

CENTRAL HIGH SCHOOL FACULTY. Principal Hassie K. Gresham and teacher Nannie Lee Hicks were members of the same faculty for many years. Miss Gresham is pictured at the center, right; Miss Hicks, the upper left.

116

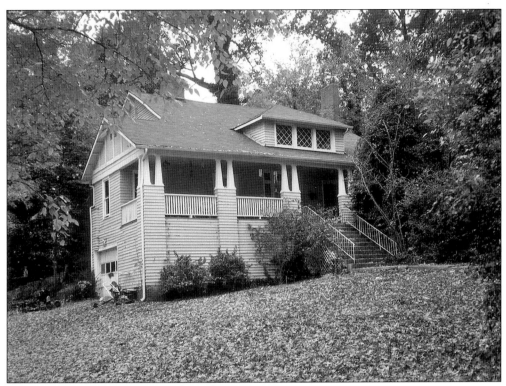

HICKS-HAGLER HOME. Miss Hicks and her sister, Eva Hicks Hagler, a music teacher in the Knox County Schools, lived in this house on Colonial Circle, just past the north end of Fountain City Park. The beauty of the flowers and shrubs in their yard and garden was unexcelled.

MARY FRANCES HOUSLEY (1926–1951). On January 14, 1951, Mary Frances was a stewardess on National's Flight 83. While landing in Philadelphia in a driving snow, the plane overran the runway, plunged through a fence, and ignited from the high-octane fuel. Mary Frances made ten successful trips into the cabin to rescue passengers but perished on the 11th trip. Her parents were presented with the Carnegie Hero Medal in her honor. (The Central High School *Centralite*, 1944.)

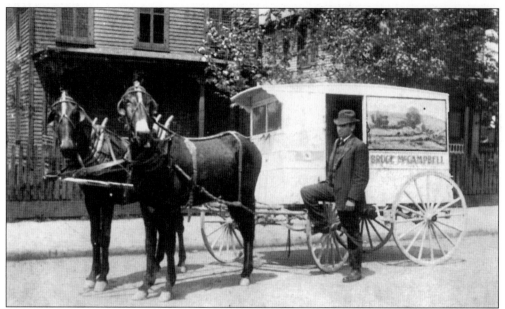

BRUCE PHILLIP MCCAMPBELL AND HIS DAIRY WAGON. Bruce P. McCampbell (1883–1929) had a 19-acre dairy farm in Beverly with around 100 Holstein and Guernsey cows. His workday was very long. The milking process started before daylight and then he had his dairy delivery route to run. (Used by permission of Janet McCampbell Harper.)

JOSEPH SAMUEL (JOE) MCCAMPBELL (1920–2000) AND BRUCE RANKIN MCCAMPBELL, M.D. (1916–1994). Having lost their father when they were very young, the McCampbell brothers were always close. Dr. Bruce, who graduated first in his class in the University of Tennessee Medical School, became a top general surgeon in Knoxville when he retired from the navy. Joe owned and managed the Smithwood Amoco Service Station. (Marguerite McCampbell Collection.)

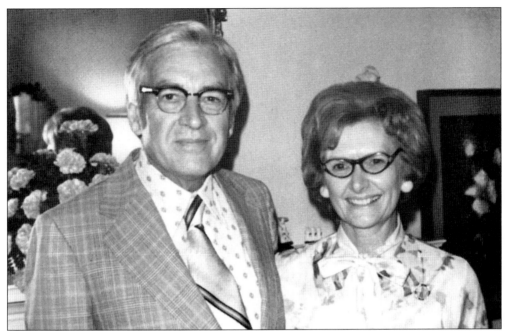

Lt. Cmdr. Bruce R. McCampbell, M.D. and Faye Williams McCampbell. Lieutenant Commander McCampbell served on the hospital ship *Mugford* in the Pacific during World War II. He received a letter of commendation from the Secretary of the Navy for his service. (Janet McCampbell Harper, used with permission.)

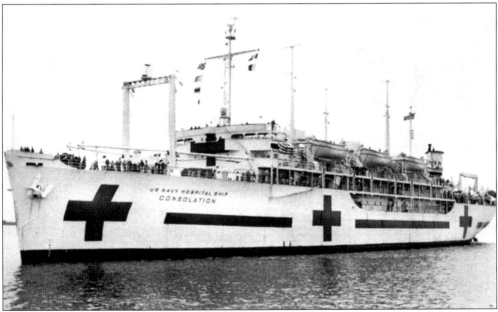

Naval Hospital Ship, the USS Consolation (1952). This ship was refitted with a flight deck for helicopters. Anchored offshore Korea, they were able to receive the injured within 15 or 20 minutes—1,200 in a three-day period with only three deaths, an extraordinary record. Lieutenant Commander McCampbell received another letter of commendation for his service in the Korean War. (Janet McCampbell Harper, used with permission.)

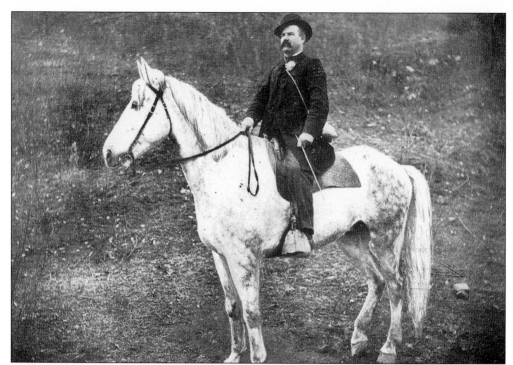

GIDEON HILL MORGAN, M.D., (1852–1915) ON HORSEBACK. Morgan's medical office was in the City of Rogersville until 1902, but he covered a 40-mile radius on horseback. He had a remarkable reputation as an expert with fever cases. During one typhoid epidemic he rode day and night and treated 383 cases in one year, losing only two patients.

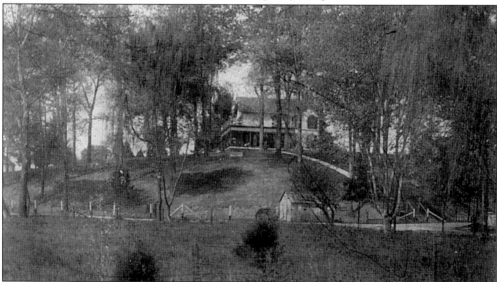

LAKE VIEW (C. 1913). When his Rogersville office burned, Dr. Morgan decided to move to the Knoxville area. The family bought a home on five acres in Fountain City and arrived in 1902. It was at the height of a depression and the house had been allowed to deteriorate, but he hired several men and soon had it in good shape. This house is now the Gentry-Griffey Funeral Chapel. (Photograph from Dr. Morgan's autobiography.)

KYLE H. MYNATT (1907–1976).
Kyle Mynatt had his first funeral
home in Halls, but later moved
across the street from "The
Station" in central Fountain City.
(Kyle H. Mynatt Collection.)

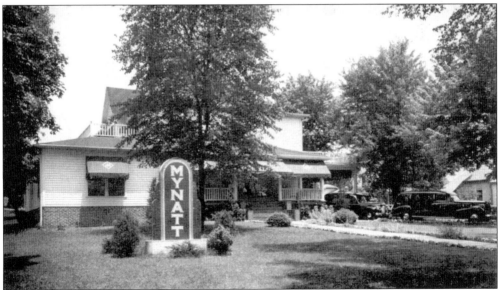

MYNATT FUNERAL HOME (1946). In 1929, Mynatt bought the old Conner home on Rennoc
Road and remodeled it. A brochure printed in 1946 contained this photograph of the large,
attractively remodeled home. (Kyle H. Mynatt Collection.)

CHARLES L. (1892–1946) AND OPAL NELSON PRATT (1898–1982). In the early 1920s the Pratts founded a family grocery in Smithwood that has been in operation for over 80 years with only brief interruptions. Many of their four daughters (Wilma, Thelma, Betty, and Johnnie) and five sons (Sam, Charles L. Jr., Ralph, Richard, and William) worked in the store over the years. (Betty Pratt Adams Collection.)

PRATT BROTHERS MARKET (C. 1950). Originally, the store "stocked a complete line of everything," according to Ralph. Today, Ralph, his sister Betty, and Ralph's children now manage the store as a fresh produce market. (Betty Pratt Adams Collection.)

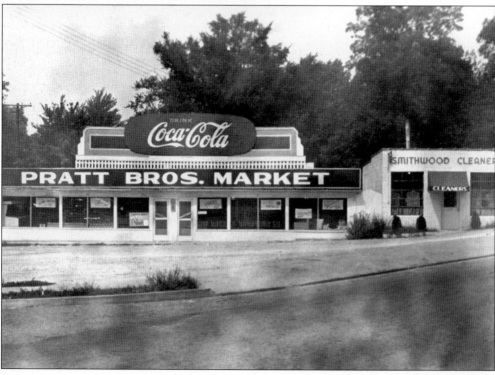

LUCY CURTIS TEMPLETON (1878–1971). Lucy Templeton joined the staff of the *Knoxville Sentinel* in 1904 as a proofreader with a salary of $5 per week. At the time she was the only woman who had ever "invaded" the all-male second floor newsroom. Templeton soon won over the men with her ability to handle the crises that arise in the newspaper business. (Reprinted by permission of *The Knoxville News-Sentinel* Company.)

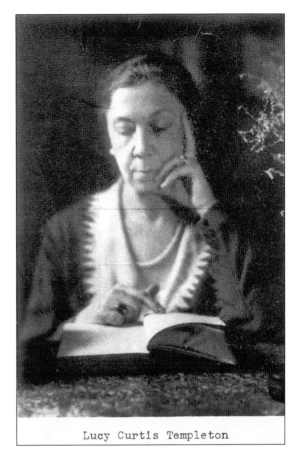

Lucy Curtis Templeton

CURTIS FAMILY HOME. Beginning in 1926 until well into her 80s, Lucy Curtis Templeton wrote a column called "A Country Calendar." The column discussed gardening, birds, Greek mythology, books, and many other subjects. The gardens and shrubs at her family home on Black Oak Ridge (below) or at her bungalow nearby furnished the material for her essays. (Reprinted by permission of *The Knoxville News-Sentinel* Company.)

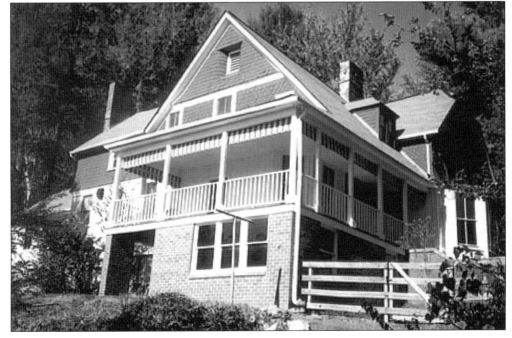

WILLIAM SHERMAN WALLACE (1889–1965). This is a 1950 photograph of Sherman Wallace (left, with unidentified customer), who mentored Roy Acuff and many others through their teen years. Roy honed his musical skills in Wallace's Barber Shop and at John I. Copeland's Garage after his days at Central High School. (Ruth Ford Wallace Collection.)

WALLACE'S MECHANICAL HORSE. A free ride made a boy's first haircut an experience to remember. Here, Charles Duncan (1902–1988), James Franklin "Jim Ted" Collins (1923–2003), and style shop owner Ray L. Wallace (1921–) are having a little fun between patrons. Charlie and Jim Ted were the chief greeters at the shop for many years. (Ruth Ford Wallace Collection.)

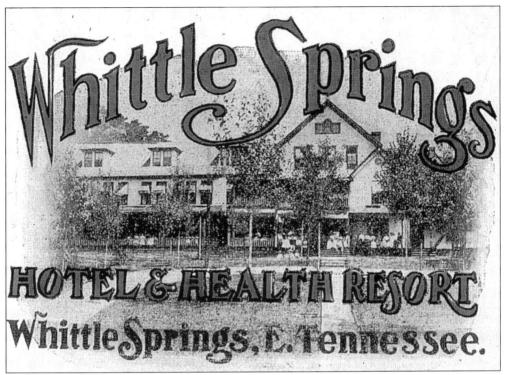

WHITTLE SPRINGS HOTEL AND HEALTH RESORT. James M. (Jim) Whittle (1850–1944) used a divining rod to locate three sites for wells near the one visible surface spring and built his first 10-room house on the 50-acre tract in 1890. (Ronald R. Allen Collection.).

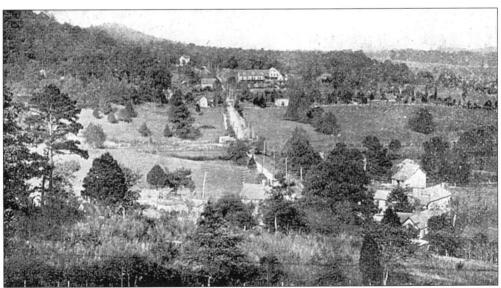

VIEW OF THE HOTEL FROM SHARP'S MOUNTAIN. The Fountain Head Dummy Line ran through the valley, bringing visitors on day trips as well as overnight guests to Whittle Springs Hotel and Resort. (Ronald R. Allen Collection.)

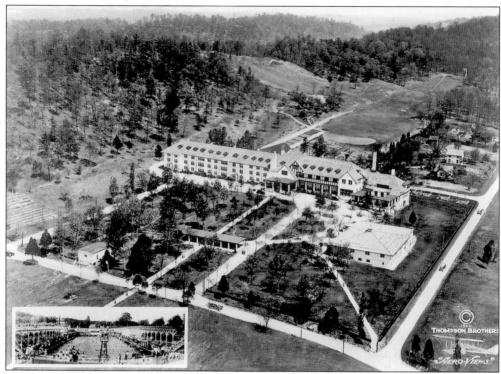

THOMPSON AERIAL VIEW OF WHITTLE SPRINGS HOTEL AND RESORT. This Thompson Brothers "Aero-View," made after the $650,000 expansion of the resort hotel in 1917–1918, shows the large springhouse and dancing pavilion. (Thompson Historic Photographs, used with permission).

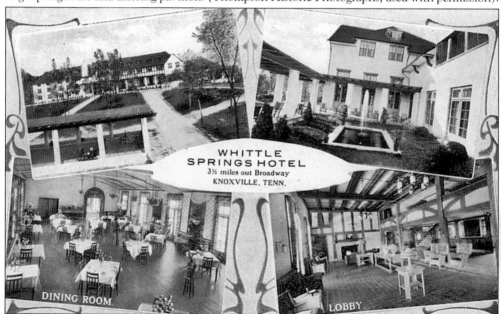

FOUR VIEWS OF HOTEL FEATURES. This unusual postcard shows the springhouse, the formal garden behind the hotel, the elegant dining room, and the lobby of Whittle Springs Hotel and Resort.